LANDMARKS &
HISTORIC SITES OF
LONG ISLAND

LANDMARKS &
HISTORIC SITES OF
LONG ISLAND

RALPH F. BRADY

THE
History
PRESS

Published by The History Press
Charleston, SC 29403
www.historypress.net

Copyright © 2012 by Ralph F. Brady
All rights reserved

First published 2012
Second printing 2013

Manufactured in the United States

ISBN 978.1.60949.726.2

Library of Congress Cataloging-in-Publication Data

Brady, Ralph F.
Long Island lore : a history and guide to historic sites on New York's Long Island / Ralph
F. Brady.
p. cm.
Includes bibliographical references and index.
ISBN 978-1-60949-726-2
1. Historic sites--New York (State)--Long Island--Guidebooks. 2. Historic buildings--New
York (State)--Long Island--Guidebooks. 3. Long Island (N.Y.)--Guidebooks. 4. Long Island
(N.Y.)--History, Local. I. Title.
F127.L8B73 2012
974.7'21--dc23
2012025319

CONTENTS

PREFACE

This book is the story of two journeys. The first is a record of my travels over the length and breadth of Long Island to visit its historic sites and learn the stories behind them. The second journey, which is more personal, took me through a time in my life when I had to face the challenge of cancer.

I was diagnosed with papillary thyroid cancer late in the summer of 2011. If you are going to get cancer in any form, this is one of the ones that will not kill you. It is highly treatable and easily contained, but it still becomes an overwhelming presence in your life and affects everything that you do.

Around that same time, I attended a program at a local library on the history of Long Island. The man who conducted the lecture had visited some historic building sites and prepared a slide show for the mostly senior citizen audience that was in attendance. I assumed that he would have also written a book about the subject and was disappointed to learn that he had not. It had become obvious to me that I needed something to take my mind off the cancer and what the treatment might do to me, and so I decided to begin my own research and write the book myself. The journey that I began at that time introduced me to some remarkable people who are part of Long Island's history and helped me to get through a difficult time in my life. Their stories gave me an entirely new outlook on history, and I know that as long as I live in this area and drive on its roads, I will never look at Long Island the same way again.

As we go through our lives, we are continually exposed to some aspect of history. It is part of the daily curriculum during our years of formal

education, but at the same time, when we are not in a classroom, we are still being taught history on a more personal level. We may learn about the discovery of America, Lincoln's assassination and the two world wars in a classroom setting, but we are also learning a different kind of history in our homes. Our parents fill us with stories about their childhoods, humorous anecdotes about some relative or friend and even Mom's recipe for meatloaf that becomes a part of the history that we carry with us through our lives. Most of this knowledge fades into our memory as time passes and new experiences overshadow it, but it never leaves us entirely. It is always there, just waiting for some stimulus to bring it to the forefront, and recalling those memories is what keeps history alive.

Therein lies the purpose of this book and the culmination of that journey into Long Island's past. The path that I have laid out for you will take you to a place where Native American people settled thousands of years ago and later used seashells as their currency to trade with European settlers. It will follow the rich aviation history of Long Island and what that meant to our country in World War II. There will be tales of mansions built with the fortunes of America's great families, as well as simple homesteads where people struggled to merely survive in the New World. Along the way, we will visit the homes of artists and writers who contributed to the rich heritage that is our country's history and even touch on a time when American foreign policy originated at a president's vacation home in Oyster Bay.

So if after reading this book you decide to embark on your own journey, you are in for an adventure into the past. In most cases, the places are still there, but it is the stories of the people that will affect you the most. So get out your maps or program your GPS and tuck this book under your arm as you set out to explore Long Island. Theodore Roosevelt, Walt Whitman, Charles Lindbergh and many others await you, as you learn a little more about why they chose to make Long Island a part of their lives.

Ralph F. Brady

ACKNOWLEDGEMENTS

This book would not have been possible without the efforts of the many volunteers who share my love of history and donate their time to keep it alive. They work in the various historical societies that exist in many of our towns and write the pamphlets or set up the websites that provide so much information. Many of them volunteer at historic buildings or museums and are always eager to share their knowledge of some aspect of history that is their particular interest. In some cases, they dress up in period costumes and conduct tours of historic sites to make the experience of learning about history even more fulfilling. Their contributions are present throughout this writing, but the final book could not have taken shape without the efforts of two very special people.

My partner on this journey was my wife, Madeline, who traveled Long Island with me to visit many of these sites. That was certainly the enjoyable part of the journey, but the major part of her contribution to the book was just plain old hard work. She helped me through the technical aspects of preparing a manuscript on the computer and then read through all of the work and corrected my typing errors.

The person who really championed my cause and got this book published is Ms. Whitney Tarella of The History Press. For reasons that I will probably never know, she took a chance on me as a novice writer, guided me through the publication process and taught me how to organize a manuscript along the way. If the completed work can justify Whitney's faith in me, I will regard the book as an overwhelming success.

Part I

NASSAU COUNTY

Chapter 1
TOWN OF HEMPSTEAD

ST. PAUL'S SCHOOL

An Irish immigrant named Alexander Turney Stewart left home in 1823 and achieved the American dream of riches and success in business. When he died fifty-three years later, his wife decided to honor his memory by erecting several buildings in his name. One of the most magnificent of these now stands empty and decaying, but the community in which it stands may yet be able to breathe new life into it.

Stewart was born in Ireland and had originally intended to become a minister. He decided to forgo that career and came to the United States, where he worked for a short time as a teacher in New York City. When his grandfather passed away and left him some money, Stewart returned to Ireland to collect his inheritance. He used that money to purchase some Irish linens and laces and then returned to New York to open a store. While enjoying some immediate success with his modest store, he married Cornelia Mitchell Clinch whom he had met at a local Episcopal church.

Young Alexander's approach to retail merchandising was innovative in many ways, and his one store grew to a mighty retail empire known as A.T. Stewart and Company. He expanded his operations to make them worldwide and also owned his own mills and factories, which was unheard of for retail companies at that time. His two New York City department stores known as the "Marble Palace" and "Iron Palace" were among the most successful, and he pioneered a mail-order business that produced even more profits. In the

middle years of the nineteenth century, the financial industry ranked Stewart as one of the wealthiest men in the United States. With a net worth of more than $40 million in 1876, he placed just slightly behind more commonly known industrial giants like Vanderbilt and Astor.

Around the time of his death, Stewart was building housing for his employees in the town of Garden City. His widow, Cornelia, decided to build something a little more impressive in his memory and erected the Cathedral of the Incarnation, the Garden City Hotel and St. Paul's School. While the cathedral and hotel thrived in the years that followed, the school that was built in 1879 has been vacant for many years.

It is generally described as being of High Victorian Gothic design, and the building is constructed of red brick. It contains five hundred rooms and is topped by gothic spires and gargoyles. For many years, it served as an all-boys' preparatory school, owned by the Episcopal Diocese of Long Island, but it was purchased by the Town of Garden City in 1993 for $7.25 million. The Committee to Save St. Paul's, along with the Garden City Historical Society, is committed to preserving the building and finding a new use for it. Among the proposals being considered are its conversion

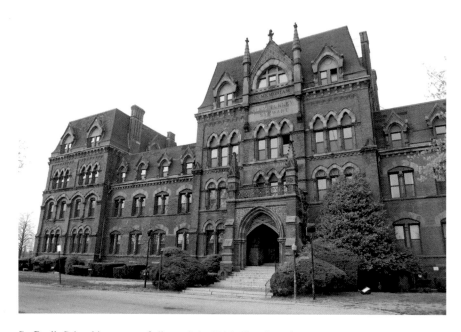

St. Paul's School in a state of disrepair in 2012. *Photo by author.*

to affordable housing or an assisted living facility for senior citizens. The debate continues, but in the end, it may go the way of so many other historic buildings on Long Island and be demolished. It is presently listed on the U.S. National Register of Historic Places, and the time may be running out to go and see it in person. It is located at the west end of Stewart Avenue in Garden City, adjacent to soccer fields and the Garden City Golf Club, and is impossible to miss.

VANDERBILT MOTOR PARKWAY

Without a doubt, the largest (or at least the longest) historic site on Long Island is the old Vanderbilt Motor Parkway. It was originally scheduled to run from the New York City border all the way to Riverhead, a distance of seventy miles. When finally completed, it ended up terminating at Lake Ronkonkoma, which made its total length closer to forty-five miles. It was planned to be part of an automobile-racing course that would emulate the great road racecourses of Europe, with the more practical use of being the first roadway in the United States to be designed exclusively for automobiles.

William Kissam Vanderbilt II, the great-grandson of Cornelius Vanderbilt, was an automobile racing enthusiast who had enjoyed success on the European road racing circuit. In addition to victories in some of Europe's premier road races, he also set course records at some of the better-known events. With the dream of bringing this type of racing to the United States, he created a series of competitions that became known as the Vanderbilt Cup races.

The first race took place on October 8, 1904, over a thirty-mile-long triangular course consisting of public turnpike roads. There was a good deal of local opposition to the race until it was realized that wealthy spectators would pay as much as twenty-five dollars for a good parking place near the racecourse. The first race drew an estimated fifty thousand spectators, and residents of the areas that it ran through quickly dropped their opposition to having a bunch of daredevil drivers racing through their neighborhoods.

During the next several years, there were a number of serious accidents in the race, and Vanderbilt decided to build a safer roadway that would provide more protection to drivers and spectators alike. He acquired additional

land and created a company to build a private toll road that would have no intersection crossings. It would include bridges and overpasses to allow local traffic to pass over it. The new parkway, when opened in 1908, was state-of-the-art for its day and included banked turns, guardrails and a reinforced concrete tarmac surface. Vanderbilt's racers would no longer be competing on a dirt road, and he and his rich friends would now be able to commute to New York City as fast as they wished on the private road, without fear of being ticketed for excessive speed on a public highway.

By 1911, the parkway had been extended as far as Lake Ronkonkoma. There were only fourteen entrance and exit points along its entire length, and the toll to use the road was set at two dollars. Over the years, to encourage more public usage of the route, the tolls were lowered several times and ended up being only forty cents by 1938. Much of this was in response to the work of Robert Moses, who was in the process of constructing free access motor parkways all across Long Island. Faced with this competition, rising maintenance costs and steadily declining revenues, Vanderbilt's managing company fell behind on tax payments to New York State. To settle the tax lien, the parkway was sold to the

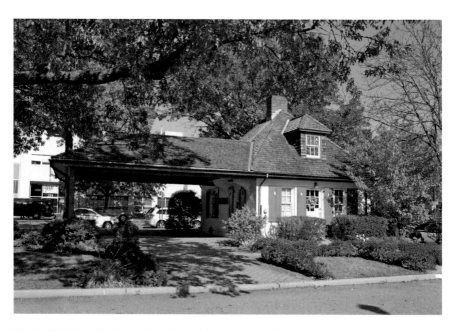

Vanderbilt Motor Parkway toll collector's house, presently being used by the Garden City Chamber of Commerce. *Photo by author.*

State of New York for $80,000. It was finally closed in 1938, but remnants of it still survive all across Long Island.

Some parts of the old highway exist as the Long Island Motor Parkway, running from Dix Hills to Ronkonkoma, while other sections have now become local streets or biking and hiking trails. Some of the more interesting features preserved are the old toll collector houses, many of which have been converted into private homes. One of the best examples of these is presently occupied by the Garden City Chamber of Commerce and is located on Seventh Street in Garden City, just east of Franklin Avenue. This one was originally located on Clinton Avenue but was moved to its present site in 1989. Very little of the original parkway remains to remind us of the days of roaring engines, the squealing of narrow tires and men with no helmets or seatbelts in open cars, racing over the length of the Vanderbilt Motor Parkway.

ROOSEVELT FIELD

More commonly known as a popular destination for shoppers throughout the New York metropolitan area, Roosevelt Field was at one time the most significant site in the aviation history that was made on Long Island. It was originally known as the Hempstead Plains Aerodrome, but it was renamed in honor of President Theodore Roosevelt's son Quentin, who was killed in aerial combat during World War I.

The original aerodrome covered an area of approximately one thousand acres, running just east of the present Clinton Road and south of Old Country Road. As early as 1909, motorcycle racer and aviation enthusiast Glenn Curtiss was experimenting with early biplanes over this area, when it was no more than a large grassy meadow. By 1911, other early aviators, including A.L. Welsh, who had been trained by the Wright brothers, flocked to the Hempstead plains to hone their flying skills and try out new aircraft designs. Prior to World War I, Quentin Roosevelt underwent flight training on the portion of the aerodrome that was known at that time as Hazelhurst Field and later incorporated into Roosevelt Field.

By the end of the war, the field also served as an airbase for lighter-than-air flying craft known as dirigibles. On July 6, 1919, a 643-foot-long British

dirigible landed at Roosevelt Field, having completed the first transatlantic crossing by an airship of its kind. Just prior to that landing, Major J.E.M. Pritchard made history by parachuting from the craft, thereby becoming the first person to accomplish a parachute jump from a dirigible. The field was the site of world-famous air races, as well as aviation records for speed and endurance. In 1923, the first nonstop transcontinental flight also departed from Roosevelt Field, and early filmmakers found the location ideal for the production of films about pioneer aviators. In 1924, the first American attempts at skywriting, which had been invented by Major Jack C. Savage of the British Royal Air Force, also took place at Roosevelt Field. All of this can be said to have merely set the stage for its greatest contribution to history, which was still to come.

In 1919, a French businessman named Raymond Orteig offered a prize of $25,000 to the first person to fly nonstop between New York and Paris. In the years that followed, there were numerous failed attempts to accomplish this, some of which resulted in fatal crashes. Finally, on May 20, 1927, a twenty-five-year-old U.S. Air Mail pilot named Charles Lindbergh took off from Roosevelt Field and landed at Le Bourget Field near Paris, thirty-three

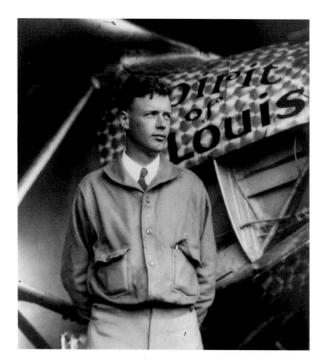

Charles Lindbergh with the *Spirit of St. Louis* at Roosevelt Field prior to his historic flight. *Courtesy of Garden City Archives.*

hours and thirty minutes later. He captured the Orteig prize and went on to achieve worldwide fame and the nickname "Lucky Lindy," because against all odds and thanks to good weather, he had accomplished what was then thought to be impossible.

Roosevelt Field continued to be either the takeoff or landing point for world-record aviation feats, including those set by women who were just beginning to be recognized in the field. By the early 1930s, development on Long Island started to claim parts of the huge aerodrome property. In 1936, the eastern field was sold and became a racetrack, while the western portion of the property continued to operate as an aviation center. At its peak, Roosevelt Field was regarded as America's busiest civilian airport and was also used by the armed forces during World War II. After the war, it again became a commercial airport until its closure on May 31, 1951.

If you can find a clear spot to stand on, just south of Old Country Road on Zeckendorf Boulevard, and look east to Merrick Avenue, you are on the takeoff path used by Charles Lindbergh. Had you been there in 1927, you would have been able to cheer as "Lucky Lindy" left the ground, dipped his wing and started off on the adventure of a lifetime and into aviation history.

Nunley's Carousel

No family visit to Museum Row in Nassau County would be complete without a stop at Nunley's Carousel. While older children may find a ride on the carousel a bit tame for their tastes, younger children and adults with a sense of nostalgia will delight in the experience.

The carousel on display was built back in 1912 in an era when New York City was home to a number of very popular amusement parks. It was constructed almost entirely of wood and featured thirty jumping horses, eleven standing horses, a lion and two chariots. A two-year restoration project has brought this one-hundred-year-old example of amusement park history back to its original condition.

The Nunley family name was synonymous with amusement park operations for three generations. From 1912 to 1939, this carousel operated in a section of Brooklyn known as Canarsie. Since the family operated amusement parks at four other locations in the New York area, most area

residents who grew up any time from the 1940s up until the 1990s have some memories of a day's outing at a Nunley family entertainment center.

In 1939, William Nunley moved the carousel from Brooklyn to Baldwin, where it continued to operate until 1995. With the carousel as a focal point, he built a small amusement park named Happyland around it and offered what has come to be known as "fast food," along with vintage arcade games. There was also a selection of other children's rides, and for years, parents who brought their children to Happyland would regale them with stories of their own childhood experiences. Singer/songwriter Billy Joel also experienced fond memories of visits to Nunley's Happyland, and he dedicated a piece of classical music to the carousel. The piece was entitled "Waltz No. 1 (Nunley's Carousel)," and it was included in his 2001 album of classical music entitled *Fantasies and Delusions*.

As people's tastes in amusement parks changed, quaint little Nunley's Happyland and its carousel became less profitable, while the value of the land that it occupied increased dramatically. In 1995, the park closed, and the carousel was placed in storage until 2006. It had been purchased by Nassau County in 1998 because of its historical value and was shipped to

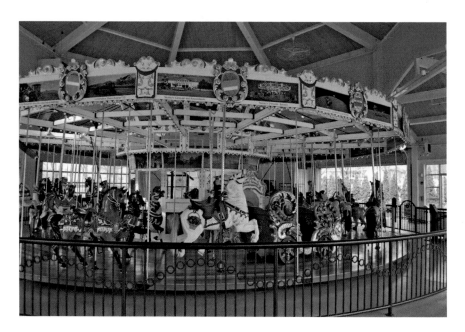

The carousel in 2012 after restoration. *Photo by author.*

A building housing Nunley's Carousel on Museum Row in Garden City. *Photo by author.*

Mansfield, Ohio, for a two-year restoration project that began in 2007. Although the county did fund most of the restoration, part of the cost was paid for by a fundraising campaign named "Pennies for Ponies" that was begun by a young student from Wantagh.

As part of the development of Museum Row in Garden City, a new building was built to house the carousel, and it began operating again in 2009. The Wurlitzer organ is still playing background music as children of all ages mount their one-hundred-year-old horses and gallop off into the past, a past when life was simpler and it didn't take a two-hundred-foot drop on a roller coaster to give us a thrill.

MITCHELL FIELD

Unless something has piqued their curiosity about the old buildings that they see every day, many of the students at Nassau Community College in Garden City will have no idea of the history surrounding the college grounds. Once known as Mitchell Field, the property was established as a U.S. Army Air

Corps base in 1917. It was originally designated Hazelhurst Aviation Field #2 but was renamed in honor of former New York City mayor John Purroy Mitchell, who was killed in Louisiana while training for air corps service.

The present Garden City and Hempstead areas were a hub of aviation activity in the period leading up to World War I. During the war, Mitchell Field served as a training base for army pilots on the Curtiss "Jenny" biplanes. In 1919, after the war, an aircraft operated by Lawson Air Lines flew into Mitchell Field from Milwaukee, Wisconsin, making that the first cross-country flight by a multi-engine passenger aircraft with a closed cabin. The year 1920 saw another first, with four army De Havilland DH-4s making a round-trip flight between New York and Nome, Alaska. Mitchell Field was also the site of the completion of the first transcontinental airmail flight, several world-renowned air races and numerous speed and distance records.

In the period between the two world wars, the base continued to grow and was regarded as the Army Air Corps premier air base. In 1938, a group of army B-18 bombers set out to complete the first nonstop transcontinental flight by bomber aircraft. Mitchell Field was also the sight of the first long-

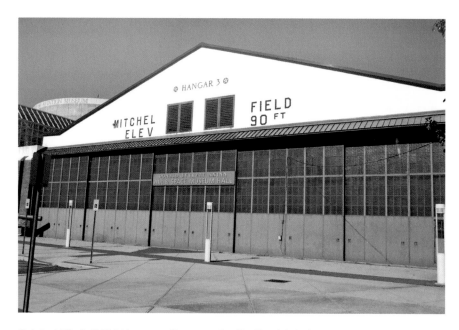

Original Mitchell Field hangar adjacent to the Cradle of Aviation museum. *Photo by author.*

range military air reconnaissance flight, and in 1939, three B-17 bombers led by then lieutenant Curtiss LeMay flew 750 miles out to sea and intercepted an Italian ocean liner that had been chosen to be a part of the test.

During World War II, two squadrons of P-40 fighter aircraft based at Mitchell Field were the main line of defense for New York City in the event of an enemy air attack. By the late 1940s, the base was the headquarters for the Air Defense Command, First Air Force and Continental Air Command but was relieved of the responsibility for the protection of New York City because of concerns about operating tactical aircraft in an urban area. Several aircraft crashes near the field created an atmosphere of public pressure that ultimately led to the closure of the base in 1961. The property was turned over to Nassau County and today houses a number of museums, including the Cradle of Aviation Museum.

Two of the original hangars still exist just to the right of the museum's entrance, and there are additional original buildings that lie along the south perimeter of the Nassau Community College campus. There is no better way to appreciate the remarkable history of this part of Long Island than to visit the Cradle of Aviation Museum and experience some of its exhibits. Where school buses now park after dropping students for a day's outing at the museums, P-40 Warhawk aircraft once roared off runways to protect the skies over the New York area.

Chapter 2
TOWN OF NORTH HEMPSTEAD

SADDLE ROCK GRIST MILL

Because of its rich history dating back to colonial times, it is only natural that Long Island would be the site of a number of village gristmills. One of these is in the small village of Saddle Rock, a part of the larger surrounding community of Great Neck. While other preserved gristmills in Stony Brook and Watermill were built to be powered by the flow of fresh water from ponds or streams, the Saddle Rock mill is unique in that it uses the tidal flow of the waters of Little Neck Bay for much of its power.

The name Saddle Rock was chosen for the village because of an unusual saddle-shaped rock that was visible just off shore in the bay. As early as the late 1600s, most of the village was composed of the estates of a number of prominent local families. Of these, the Eldridge family seems to have been one of the earliest owners of the mill, which dates back to 1700. It was constructed of locally available materials and housed milling machinery brought over from England. Most of its output consisted of flour ground from locally grown corn, and its location alongside Udall's Pond, with direct access to Little Neck Bay and Long Island Sound, made it ideal for commercial vessels. Trading ships would travel up the East River from the Atlantic Ocean or across Long Island Sound from New England and load up with flour that could be sold anywhere in the world. Sailors would often

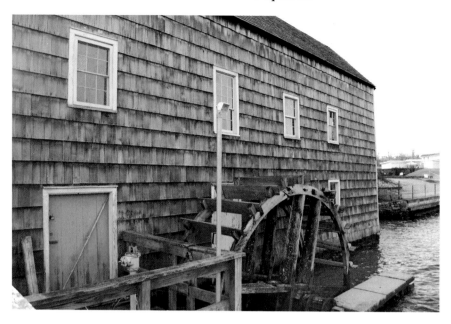

Saddle Rock Grist Mill during its 2011–12 restoration. *Photo by author.*

carve the names of their ships in the wood timbers of the mill, and many of these old carvings are still visible at the mill today.

The Saddle Rock Grist Mill remained in the hands of the original families that owned it and continued to operate until 1940. In 1926, during the tenure of Louise Eldridge as mayor, the gristmill also served as the village hall for public meetings. Ms. Eldridge was the first female mayor in the state of New York and served until 1947. In 1950, the Eldridge estate was sold to a developer, and in 1955, the mill became the property of Nassau County, which has preserved it as a museum. It is listed in the National Register of Historic Places and is easily reached off Exit 33 of the Long Island Expressway. The mill is several miles north of the Expressway, and the route winds through a number of lovely neighborhoods. There are several green historic signs along the route marking the way to the mill. The surrounding park was undergoing restoration in the winter of 2011, and additional information regarding its reopening and hours of operation can be found at the village website, which is www.saddlerock.org. The view from the Saddle Rock Bridge of the East River crossings into New York City and the Manhattan skyline makes a visit to Saddle Rock an enjoyable day trip.

SANDS-WILLETS HOUSE

It is unusual to find a restored historic home that commemorates the lives of two different families in two different eras. The Sands-Willets House, located in the village of Flower Hill, does just this by showing what life was like in the eighteenth and nineteenth centuries.

The house is believed to have been built around 1715 as a four-room, one-and-a-half-story home with a full basement. The Sands family that occupied the home from 1715 to 1845 are among the earliest settlers in the area, and their name was given to the village of Sands Point when it was incorporated in 1917. They were a typical family of the period, working as farmers and merchants, and seven members of the family served in the Colonial Army during the American Revolution. Little is known about how these men fared during the fighting, but there is a record of a John Sands II having risen to the rank of colonel.

In 1845, the property was purchased by Edmund Willets, a prominent Quaker and abolitionist. He built an addition to the original house described as Greek Revival in style, bringing the total number of rooms up to eighteen. Willets is known to have advocated education for slaves, and in 1820, he

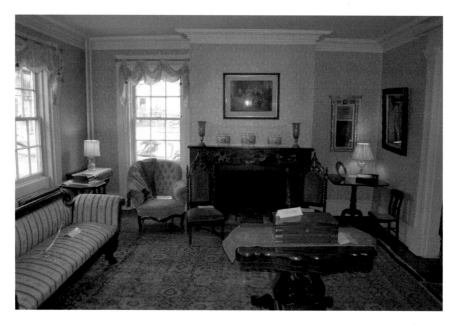

Living room at the Sands-Willets House. *Photo by author.*

embarked on a six-week journey throughout the eastern states to meet with like-minded Quakers. He appears to have included a visit to Washington, D.C., on his trip, but there is no record of any official meetings with government officials to voice his opposition to slavery. The house remained in the Willets family for several generations up until 1967.

The Sands-Willets House was purchased by the Cow Neck Peninsular Historical Society and is listed on the National Register of Historic Places. Restoration has continued unabated and included uncovering the kitchen hearth that had been bricked over. The original colonial kitchen has been re-created down to the smallest detail and is filled with antiques and artifacts from the period. In Willets' addition to the house, visitors will find fully furnished rooms with beautiful wallpapers that lend elegance to the décor.

The house is located at 336 Port Washington Boulevard, on the west side of the road, just south of the town's shopping area. Individual tours may be scheduled by appointment, and regular tours for the public are conducted on the first and third Sundays of every month up until October. If you find two history lessons "for the price of one" to be appealing on your journey to learn more about the history of Long Island, this is one stop that cannot be missed.

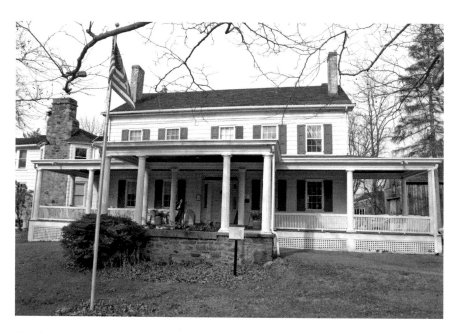

Exterior view of the Sands-Willets House. *Photo by author.*

CEDARMERE ESTATE

There is an unusual elevated roadway on Long Island known as the Roslyn Viaduct. It passes over a lovely shopping area in the village of Roslyn Harbor and crosses a narrow stretch of water that is part of Hempstead Harbor. On a road named Bryant Avenue, running north from the downtown area, lies a home that belonged to one of America's most influential poets.

William Cullen Bryant was born in 1794 and is commonly described as a "romantic poet," as well as a journalist and newspaper editor. His family's roots could be traced back to original passengers on the *Mayflower*, and he lived and practiced law in Massachusetts until 1825. He was an avid writer who contributed work to many of the foremost literary journals of that time and was generally considered quite liberal in his political views. As a strong opponent of slavery, in 1829 after becoming editor of the *New York Evening Post*, he was instrumental in founding the Republican Party and helping to elect Abraham Lincoln to the presidency.

Bryant had a lifelong love of poetry, and his first work was published when he was just ten years old. At age fourteen, an entire book of his poetry was published, and later, as a scholar, he was known for his translations of Greek and Latin classical poetry. In spite of his stature as a major American figure in both the arts and politics, historians rarely give his accomplishments their due. His impact on the arts was so significant that the great American poet Walt Whitman actually considered Bryant to be his mentor.

To get away from the congestion of New York City and the pressures of his job as editor, he purchased a beautiful seven-acre property overlooking Roslyn Harbor named Cedarmere, with a farmhouse that dated back to 1787. He had the house enlarged and renovated several times and used it as a retreat until his death in 1878. The house remained in his family for several generations and was ultimately bequeathed to Nassau County by Bryant's great-granddaughter Elizabeth.

A further restoration of the house and surrounding property was commissioned by Nassau County in 2009, and work was continuing through the winter of 2011–12. *Elements* magazine has called Cedarmere "one of the most beautifully preserved and serene enclaves on the North Shore of Long Island." Visitors can stroll the grounds and enjoy the old Gothic mill, a beautiful pond and formal garden and the exhibits in the house once the

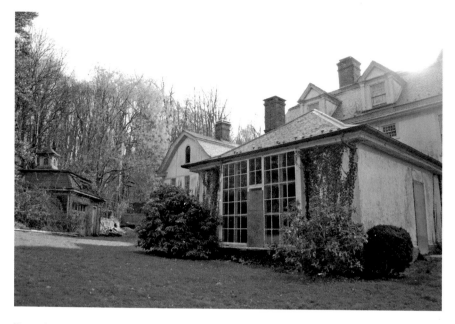

Rear view of Cedarmere showing the sunroom/porch during the 2011–12 restoration. *Photo by author.*

restoration is completed. The property is located j ' north of Northern Boulevard on Bryant Avenue, and additional information is available at the Nassau County Park's website.

Though not remembered to any great extent on Long Island, because of his involvement in the creation of Central Park and the Metropolitan Museum of Art, William Cullen Bryant is honored in New York City by having Bryant Park named after him. There is also a statue of him in that park, adjacent to the New York Public Library.

OLD WESTBURY GARDENS

Among the many estates on Long Island that have been converted to parklands and museums is the one-time home of financier John Shaffer Phipps. The estate sits on a two-hundred-acre plot in the village of Old Westbury and includes a twenty-three-room Charles II–style mansion known as Westbury House.

John Shaffer Phipps was born in 1874 in Pittsburgh, Pennsylvania, to Henry Phipps and his wife, the former Anne Childs Shaffer. The elder Mr.

Phipps was the son of an English shoemaker and settled in the Pittsburgh area. He was a childhood friend and neighbor of Andrew Carnegie, which proved to be opportune for him when he later became Carnegie's partner in the Carnegie Steel Company.

With his father's fortune and his mother's wealth from her family's successful business ventures, John was on his way to his own fortune at a very early age. He married Margarita Grace, from the Grace Shipping Lines Company, and promised her that he would build a home for her that resembled her family estate in England. The mansion was completed in 1906, and the family, which consisted of John, Margarita and their four children, moved in. The estate was actually a self-sufficient farm with vegetable gardens, orchards, a dairy and all of the required barns and buildings to support a working farm. In later years, additional acreage was dedicated to the family's interests in games, and a polo field, tennis courts and a golf course were also constructed on the property.

As the children became older, additional modifications were made to the house. The nurseries were converted to guest rooms, and separate quarters for the children were set up on the third floor. In 1911, a large service wing

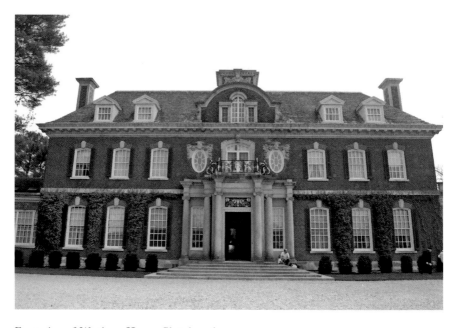

Front view of Westbury House. *Photo by author.*

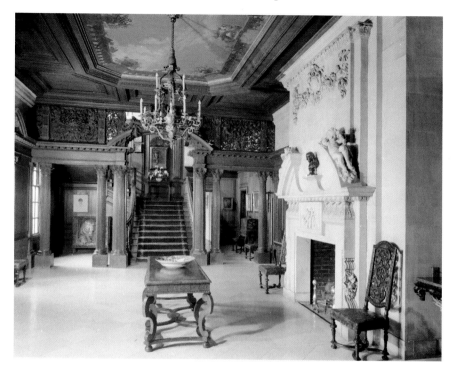

The entrance hall of Westbury House, Old Westbury Gardens, Old Westbury, Long Island. *Courtesy of the Library of Congress.*

containing a kitchen, pantry, storerooms and a dining room was added by noted Philadelphia architect Horace Trumbauer. During World War II, with England facing the possibility of an invasion, Mrs. Phipps invited thirty English children to come to Westbury House and live with the family for the duration of the war.

In 1958, after Mr. Phipps's death, the family decided to preserve the home in the manner pioneered by the British National Trust. The J.S. Phipps Foundation was established as a nonprofit institution to maintain the estate and open it to the public. Westbury House is fully furnished with antiques and artwork accumulated during the more than fifty years that the Phipps family was in residence there. The formal gardens are a delight to visit and include a miniature thatched cottage in a children's play area. The foundation hosts a variety of events on the property, ranging from museum exhibits to concerts and classic car shows. It is open every day except Tuesday during the months of April through October, and there is a small

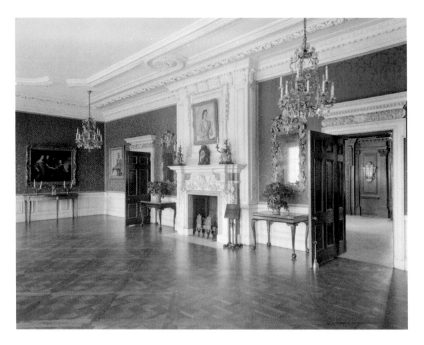

A view of the ballroom in Westbury House. *Courtesy of the Library of Congress.*

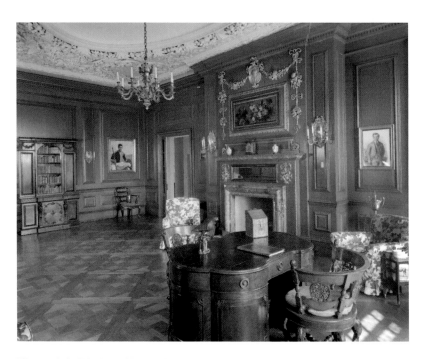

The study in Westbury House. *Courtesy of the Library of Congress.*

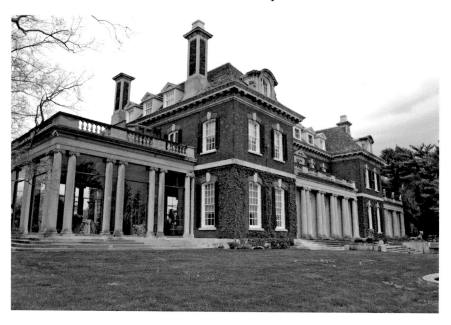

Rear view of Westbury House with enclosed sunroom on the left. *Photo by author.*

admission charge. Complete information about tours and the special events held there can be found at its website, which is www.oldwestburygardens. org. Old Westbury Gardens has been listed in the National Register of Historic Places since 1976.

JOHN PHILIP SOUSA HOUSE

There is one historic site on Long Island that this book is not going to encourage you to visit. It is a private residence in Sands Point that was the home of one of America's most famous composers, John Philip Sousa. A GPS system would take you there easily, but the route using the older method of local maps is very confusing, and the people occupying the house are entitled to their privacy. The house is included here because Sousa had such a significant impact on the history of our country's patriotic music.

John Philip Sousa was born in Washington, D.C., in 1854, the son of a Portuguese father and Bavarian mother. He was educated in the area's public schools but also studied music at a private conservatory. At the age

of thirteen, he enlisted in the U.S. Marine Band as an apprentice and was discharged seven years later. His mastery of the violin and musical composition led to positions as a violinist and conductor with various theater orchestras in Washington and Philadelphia.

By 1880, his reputation was such that he was appointed leader of the U.S. Marine Band, a position that he held for twelve years. He then formed his own civilian band, which was ranked as one of the finest symphony orchestras of its day, but his true interest lay in the area of marching music. In spite of having composed many other forms of music, including fifteen operettas, it is for his marching music that he is best remembered. Sousa had been quoted as saying that he would rather be "a composer of an inspired march than of a manufactured symphony," and as a deeply religious man, he claimed that the inspirations for his melodies came from a "Higher Power."

Among his best-known compositions are the official march of the United States Marine Corps, "Semper Fidelis," and the national march of the United States, "The Stars and Stripes Forever." Not much is known about

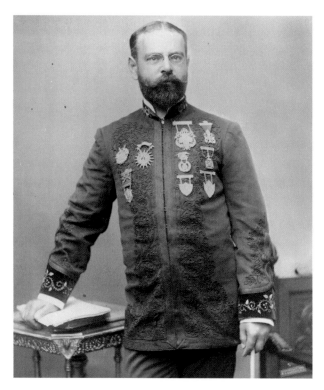

John Philip Sousa.
Courtesy of the Library of Congress.

Sousa's decision in 1915 to purchase the home in Sands Point, which he named Wild Bank. He was adamant about never retiring, and while he lived many of his remaining years at the Long Island home, he continued to travel and perform with his marching bands throughout the United States.

John Philip Sousa died on March 6, 1932, in a hotel room in Reading, Pennsylvania, after finishing a concert rehearsal with the Ringgold Band. He is buried with his other family members in Washington, D.C., and was elected to the Hall of Fame for Great Americans, an honor that only 102 persons have received. The Sands Point house was designated as a National Historic Landmark in 1966 but remains mostly unknown in the Long Island community. There are no signs designating the property as a landmark, only a small sign left there by the present owners that marks the small estate as Wild Bank.

SANDS POINT PRESERVE

One can only wonder what the wealthy were thinking years ago, when they fashioned their vacation homes to look like castles. A perfect example of this is the home known as Hempstead House, located within the Sands Point Preserve on Long Island's North Shore.

In 1900, Howard Gould, the son of railroad tycoon Jay Gould, purchased three hundred acres of shoreline property in Sands Point and began construction of a three-story, forty-room mansion. Completion of the entire estate took several years and included a huge limestone stable and servants' quarters that were modeled after Kilkenny Castle in Ireland. The main residence was designed in the style of a Tudor manor house and was finally completed in 1912. It includes an eighty-foot-high tower, reminiscent of a European castle, and was considered one of the most opulent homes on Long Island's Gold Coast.

During the course of the construction, Gould began to experience some problems in his marriage. He had married an actress named Katherine Clemmons in 1898, and it is thought that building the Sands Point estate was his attempt to please her. They nevertheless separated in 1909 and divorced later that year, with him charging her with infidelity. The other party named in the divorce proceedings was one William F. Cody, more commonly known as "Buffalo Bill."

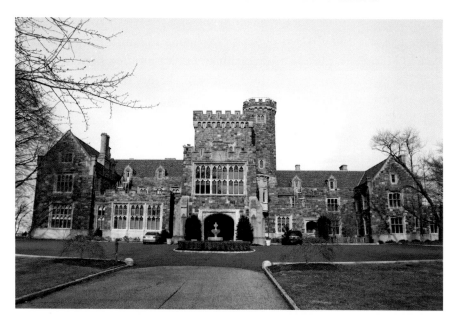

Hempstead House at Sands Point. *Photo by author.*

After the divorce, Gould continued with the construction and completed the main residence in 1912. In 1917, he moved to Europe and sold the entire property to Daniel Guggenheim for a total price of $600,000. It had cost slightly over $1 million to build, and both prices represented an enormous amount of money in the early 1900s. Guggenheim had made his fortune in mining and metal smelting and was a member of the National Security League. That organization was a driving force in altering the United States' position of neutrality and causing the country to enter World War I. The increased demand for copper and other metals as part of the war effort greatly increased the Guggenheim companies' profits.

In 1923, Daniel gave ninety acres of this property to his son Harry F. Guggenheim, and Harry proceeded to build his own summer home on the property. His home took the form of a Normandy manor house, and he named it Falaise, which is the French word for "cliff." It sits on a bluff overlooking Long Island Sound and can also be visited during a tour of the Sands Point Preserve. Unlike Hempstead House, Falaise remained furnished when the family vacated it, and it eventually became a museum.

The entire property has undergone several transformations over the ensuing years. In 1940, Daniel Guggenheim's widow, Florence, sold off the furnishings of Hempstead House and attempted to use the home as a refuge for children evacuated from Europe during World War II. When this did not prove feasible, she donated 162 acres of the estate, including Hempstead House and the stable building, to the Institute of Aeronautical Sciences. It leased and later sold the property to the United States Navy in 1946 for use as a center to design and test electronic systems for the military. At its peak in the 1950s and 1960s, this facility employed nearly eight hundred civilians, in addition to the naval personnel assigned there. When those operations were moved to Florida in 1967, the 162-acre portion of the original estate was declared government surplus.

As was the case with many other valuable historic properties, a portion of the estate was acquired by Nassau County for public recreational use. This took place in 1971, which also marked the death of Daniel Guggenheim's son Harry. In accordance with Harry's will, his ninety-acre portion of the property, with Falaise and all of its furnishings, was deeded to the county for use as a museum. With this final bequest by a member of the Guggenheim

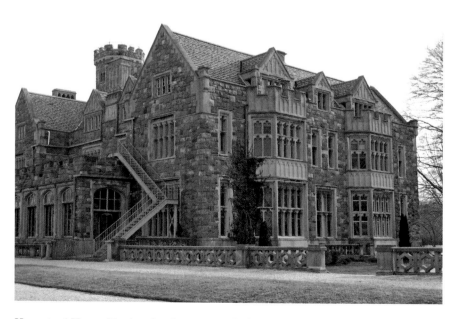

Hempstead House side view showing tower and window details. *Photo by author.*

family, the Sands Point Preserve became a reality and continues to provide enjoyment to visitors from all over the world.

The grounds of the estate are open all year long for an admission charge of ten dollars per car. Access to the homes and other buildings is restricted for part of the year, and more specific information can be obtained by calling (516) 571-7900 or through the preserve's website, which is www.thesandspointpreserve. com. There are miles of nature trails to explore, beautiful views from the bluff or beach on Long Island Sound and, what is most unusual for this type of park, you can bring your dog for the day's outing.

PORT WASHINGTON AVIATION HISTORY

An interesting chapter in Long Island's rich aviation history unfolded at an unlikely location on Nassau County's North Shore. The Port Washington North and Manorhaven communities had no airfields and no runways to speak of, but what they did have were the calm, protected waters of Manhasset Bay. This provided the perfect operating conditions for the large military and commercial seaplanes that were at the forefront of the aviation industry during the first half of the twentieth century.

In 1924, a navy pilot by the name of David Rittenhouse flew an R2C seaplane built by Curtiss Aircraft Corporation of Garden City to an amazing speed of 227.5 miles per hour, which was an unofficial seaplane speed record at that time. In a later attempt the following year, Lieutenant Alford Williams of the U.S. Navy was unsuccessful in breaking the record, which had risen to 258.8 miles per hour in the short span of one year. As aircraft speeds and sizes increased, the area set aside for seaplane operations was expanded to six thousand feet in length, and by 1937, it was ready for commercial aircraft operations.

In June 1937, regular passenger service between New York and Bermuda began out of an aviation terminal built in Port Washington. The first flight, operated by Imperial Airways jointly with Pan American World Airways, arrived in Port Washington on June 16 with only fourteen passengers. By July, with the prize of air service to Europe within its grasp, Pan Am conducted a survey flight across the North Atlantic with a Sikorsky S-42B *Clipper*. This flight pioneered the regular transatlantic service that was to come.

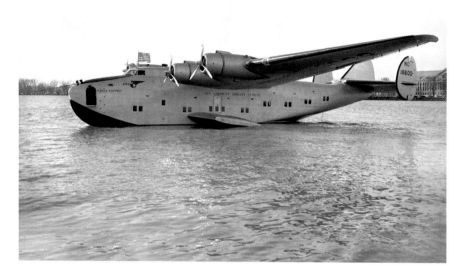

Boeing 314 *Clipper. Courtesy of Aviation History.com.*

Since 1935, Pan Am had been working with Boeing Aircraft Corporation to produce the Boeing 314 *Clipper* flying boat, the largest civil aircraft of its day. On May 20, 1939, Pan Am began the first transatlantic mail service by carrying nearly a ton of mail from Port Washington to Marseilles, France, via the Azores and Lisbon, Portugal. The flight took twenty-nine hours and was followed about a month later by a flight to Southampton, England, to open up the northern route to Europe. Then, on June 28, Pan Am began the first regular passenger service to England by a route that took the flight over Newfoundland. The *Dixie Clipper* carried twenty-two passengers who each paid a round-trip fare of $675, the equivalent of $7,000 or $8,000 in today's dollars.

In order to operate a little closer to New York City, Pan Am transferred its New York operations to La Guardia Airport's Marine Air Terminal in 1940, and though interrupted by World War II, it resumed transatlantic flights out of La Guardia until 1946. Little remains of the Port Washington/ Manorhaven operation except a maintenance hangar that is now located

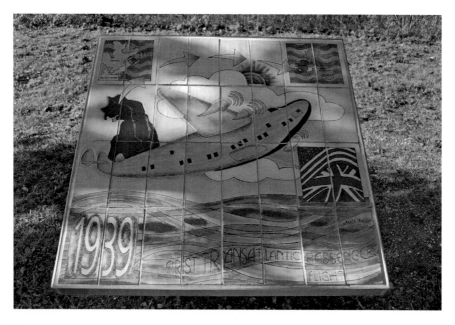

Commemorative plaque in Bay Walk Park in Port Washington North. *Photo by author.*

on a property that is part of the Brewer Capri Marina. It can be seen on the marina property or from the shore front at Bay Walk Park in Port Washington North. It has a large brown curved roof that stands out from the more modern buildings that surround it.

In 2011, to commemorate the Pan Am history in the area, the village erected a ceramic tile mural that sits on the walk in the park that parallels the harbor. There is still some seaplane activity in Manhasset Bay, but it is limited to small, privately owned or chartered aircraft. The Federal Aviation Administration refers to the area as Sands Point Seaplane Base, and a six-thousand-foot by three-hundred-foot area is designated as the runway. The glory days of the Pan Am *Clippers*, with luxurious meals and service and only forty reclining seats for nighttime travel, are nothing but a memory. But if you book a flight on one of the air taxi services that travel from Port Washington to Manhattan, you can still enjoy a part of what passengers experienced during the glory days of Port Washington aviation.

U.S. Merchant Marine Academy

The United States maintains five service academies to train officers for the army, navy, air force, coast guard and maritime service. One of these academies, the United States Merchant Marine Academy, is located on Long Island in the very picturesque village of Kings Point. Since 1874, the federal government had recognized the need for professionalism and safety in the operation of commercial vessels, but it was not until a disaster struck that Congress acted to formalize this training.

In 1934, the passenger liner SS *Morro Castle*, which had only been in service for four years and made regular runs between New York and Cuba, encountered a fierce storm just off the coast of New Jersey. To complicate matters, the captain was found dead of a heart attack in his cabin and a fire broke out in a storage locker. The crew had not conducted regular emergency drills to deal with fire or abandoning the ship with lifeboats. Many shirked their duties and left the ship, while leaving the passengers to fend for themselves. The death toll before the ship ran aground on the Jersey shore was 134, and the public was outraged as the stories of the tragedy began to be told.

The museum and administrative offices at the U.S. Merchant Marine Academy. *Photo by author.*

In 1936, Congress passed the Merchant Marine Act, and two years later, the U.S. Merchant Marine Corps was established. Training began at temporary facilities until the present site in Kings Point was obtained in 1942. Construction of the permanent academy was begun immediately and completed in fifteen months. On September 30, 1943, the new service academy was dedicated by President Franklin D. Roosevelt.

During World War II, enrollment at the academy swelled to 2,700 to meet the nation's wartime needs, and since shipboard training was such an integral part of the program, midshipmen served at sea in combat zones all over the world. During the war, 142 midshipmen lost their lives in service, and by its end, 6,634 officers had graduated from the academy. In 1945, the training program was expanded to become a four-year, college-level curriculum that later provided merchant marine officers during the Korean and Vietnam conflicts. Admission requirements were amended in 1974, and it became the first service academy to enroll women as students, thereby setting a precedent for the other four service academies.

U.S. Merchant Marine Academy graduates have continued to play a vital role in every conflict and humanitarian mission undertaken by the United

The entrance to the grounds of the U.S. Merchant Marine Academy. *Photo by author.*

States, and the school is regarded as one of the world's foremost institutions in the field of marine education. It holds a proud place in the history of Long Island, and there are signs directing the way to the academy as far south as the exit on the Long Island Expressway. The grounds are beautiful to tour, and the view out over the waters of Little Neck Bay is spectacular. There is a training ship tied up at the dock and a museum filled with historical records and ship models to delight the maritime enthusiast. It is an important part of the history of Long Island and continues to produce graduates who will write their own chapters in the history of our country.

Chapter 3
TOWN OF OYSTER BAY

FORT MASSAPEAG

It is no secret that long before European settlers discovered the "New World," the Americas were inhabited by a wide variety of indigenous people. These races that came to be known as Indians had their own cultures and complex societies, but much of this history has been lost in the development of our modern civilization. An excellent example of this part of our country's distant past lies under a small waterfront park in the town of Massapequa, and it bears the name Fort Massapeag.

Archaeologists are unclear as to whether it was built by the Massapeag Indians or Dutch settlers, but artifacts indicate that this was the site of a fort dating back to the 1640s. When this area was being developed in the 1930s, excavations uncovered more than twenty skeletons, along with numerous artifacts, that indicated use of the site by native peoples as far back as six thousand years before the arrival of Europeans on these shores. Sadly, nothing was done to protect the integrity of the archaeological site, and many of the early finds were lost to private collectors and artifact hunters.

When news of the discovery of artifacts in the area began to spread, members of the Flushing Historical Society began their own investigation and uncovered bone fragments, stone arrow and spear points, bits of old utensils and large numbers of marine animal shells. The site continued to be ransacked by amateur collectors until a local historian named Charles E. Herold persuaded the developer to preserve the site where the fort actually

stood. They erected a fence around that part of the property and planned to make it the centerpiece of the local community. Archaeologists continued to recover artifacts representing the Native American usage of the fort and items that confirmed use of the site by Dutch settlers as well.

Following up on the earlier work of Professor Robert S. Solecki of Texas A&M University, a local preservationist named John O'Halloran persuaded the Town of Oyster Bay to acquire a portion of the property and preserve it as a historical site. In 1953, the town completed the purchase and erected a marker showing some of the colonial history. The actual fort site occupied three-eighths of an acre, but it is unrecognizable, other than a slight rise on the southern perimeter where a stockade wall once ran. Scientific dating of the artifacts indicates that the story began long before colonial times.

There is evidence to suggest that the site housed a community of Massapeag Indians that used the ready supply of seashells to manufacture the Indian currency known as wampum. Before the land was filled in for development, the Indian community would have been adjacent to a salt marsh and small creek that led right out into South Oyster Bay. A parking lot and private marina now mark the entrance to the creek that still gives local boaters access to the open waters of the bay. Historians have noted that Chief Sachem Tackapausha sold the site to local settlers around 1658, but there are also colonial documents that indicate that a Dutch fortification was built there in 1656. Some of the later artifacts uncovered at the site confirm usage by the Dutch and construction of a fort that would have followed European military conventions of that time.

Among the conflicting stories about the area is an account of a massacre of the Massapeag Indians by Captain John Underhill, an Englishman working for the Dutch. The time period and actual location of the massacre are the subject of much dispute, with some historians claiming that it took place in nearby Seaford. That area has also been developed into a residential community, and in 1958, there were claims of paranormal activity in a house supposedly built upon the site of the massacre. The book written about the activities at that house later became the basis for the Hollywood movie *Poltergeist*.

Today, the Fort Massapeag site is marked by a playground and baseball field, and other than the Town of Oyster Bay's marker, there is no evidence of the earlier use of the property. The route to the site begins with Route

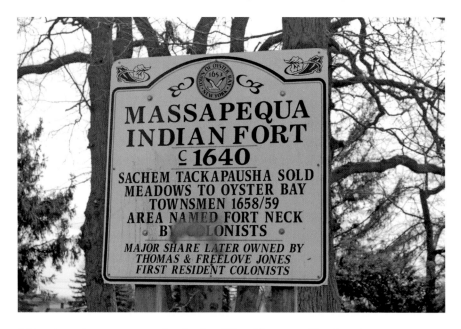

A historic marker commemorating the site of Fort Massapeag. *Photo by author.*

27A to Massapequa, heading south on Cedar Shore Drive. Near the end of the road, make a right turn on Sunset Boulevard, and the park will be one block down on the right. On your left as you pass by the marina parking lot is the creek that the Indians used to get out into the bay. Houses now sit on the salt marsh that provided the shells that they used for wampum. There really isn't any suitable place to do any digging, but I have to assume that if any of the local residents dig deep enough in their backyards, they will uncover some remnants of the Dutch or Indian use of the area. Hopefully, they will not dig deep enough to disturb any of the spirits that might lie there.

RAYNHAM HALL

Romance, espionage and a tale of unrequited love; these all sound like an ideal background for a novel or movie script, but they are actually part of the history of a historic colonial home in Oyster Bay, Long Island.

Samuel Townsend was a successful merchant living on Long Island in the early eighteenth century. He owned a shipping business and four

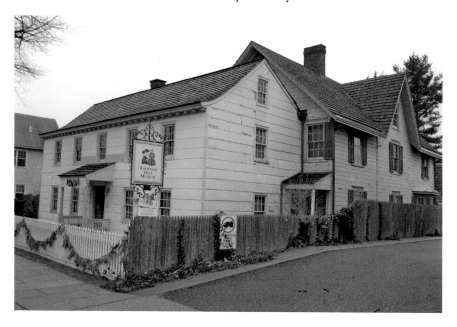

View of Raynham Hall from Main Street. *Photo by author.*

ships that traveled the world trading in a variety of goods that included lumber, molasses, pottery, textiles and rum. In 1738, he purchased a four-room frame house that now sits in the heart of downtown Oyster Bay. The property that came with the house included an apple orchard across the street, but the house itself was situated on the shore of Oyster Bay and allowed access to the harbor by a narrow meadow running down to the water. Townsend and his wife, Sarah, had eight children, so they enlarged the house to eight rooms by adding a four-room lean-to section to its north side. To market all of the different merchandise available to him through his trading, he also operated a general store out of the house, which he now called Raynham Hall.

As one of the most prosperous residents of the young town, it was only natural that Samuel would become involved in local politics. He served as both justice of the peace and town clerk and was elected to the New York Provincial Congress, which later ratified the Declaration of Independence. While most of the residents of Oyster Bay sided with the British during the American Revolution, Samuel favored independence from England. Ironically, after the Battle of Long Island in 1776, the British occupied

the town of Oyster Bay and chose Raynham Hall as the location for their headquarters. It is at this point that our little drama begins.

The military unit billeted in the Townsend home was known as the Queens Rangers, commanded by Lieutenant Colonel John Graves Simcoe. During the British occupation, the family continued to live there, and Simcoe seems to have developed some affection for the Townsends' daughter Sally. Many years later after her death at age eighty-two, a romantic poem that he had written to her was found in Sally's possessions, and historians credit it as the first known Valentine in the United States. It is beautifully written in the elegant prose of that period, and the full poem is available at the Raynham Hall museum website, www.raynhamhallmuseum.org.

Legend has it that on one occasion, another British officer named Major John Andre visited Raynham Hall and discussed Benedict Arnold's plot to surrender the fort at West Point to the British with Lieutenant Colonel Simcoe. At this point, historians differ on Sally Townsend's possible involvement in the affair. By some accounts, she is believed to have overheard the conversation and passed the information along to her brother Robert, who was already working as a spy for General Washington. Other historians, however, discount this part of the story as being a fabrication in later years to make Sally more of a heroine in a work of fiction that was based on her life. In any event, the plot failed, and Benedict Arnold's name has gone down in history as being synonymous with treachery.

The Townsend family remained prominent in Oyster Bay for several generations, and in addition to the preservation of Raynham Hall, they have also been remembered by the naming of the Townsend Square Shopping Center in the center of the village. Their home was deeded over to the Town of Oyster Bay in the early 1950s, and the Friends of Raynham Hall organization was established to oversee its restoration. Part of the house exhibits the lifestyle of the colonial era while the other part, referred to as the Victorian house, has been restored to reflect life in the 1870s. Because of Samuel Townsend's access to goods from all over the world, the furnishings in both sections are a bit more luxurious than might have been found in other homes in the village.

A day spent wandering along Main Street in Oyster Bay offers many shopping and dining opportunities, and a stop off at Raynham Hall is a fascinating way to learn more about the history of the area. If you include

a stroll through the gardens of Raynham Hall on your visit, you might be able to imagine the young British officer sitting there trying to compose his thoughts for the Valentine poem that he was writing for Sally. The first stanza begins as follows:

Fairest Maid, where all is fair
Beauty's pride and Nature's care;
To you my heart I must resign
Oh choose me for your Valentine!

OLD BETHPAGE VILLAGE

For the largest collection of preserved and reconstructed nineteenth-century buildings on Long Island, you cannot beat Old Bethpage Village Restoration, located off Exit 48 of the Long Island Expressway on Round Swamp Road. The exhibit occupies a 209-acre property, of which 165 acres were formerly a farm owned by the Powell family. It consists of fifty-one buildings, livestock and a farm, all of which provide a detailed look into Long Island's history.

The only structure that originally existed on this property is the Powell House that was built in the mid-eighteenth century by Joshua Powell. There were a number of additions made to the original house up until the mid-1800s, and it appears today as it would have looked in 1855. All of the other buildings composing Old Bethpage Village date back as early as 1829, with the exception of the Schenck House, which was a Dutch farmhouse in Manhasset back in 1765. Among the more interesting buildings are the Noon Inn, the general store, the hat shop and the blacksmith shop, all of which feature costumed guides who explain the crafts that existed back in the nineteenth century. A stop at the tavern section of the Noon Inn to sample the local nonalcoholic brew is a must to round out the experience.

Old Bethpage Village is a favorite day trip for local schools, and the volunteers and guides all give a little history lesson that makes the experience truly worthwhile for students and adults alike. There are also a number of special events scheduled to coincide with holidays or commemorate special activities from days gone by. The schedule at the time of this writing in

Layton House and Store, circa 1866. *Photo by author.*

Manetto Hill Church, circa 1857. *Photo by author.*

2011 includes a Civil War Weekend, historic baseball tournament, old-time music weekend and a "Haunted Halloween" festival. Information about activities scheduled can be found on the Nassau County Department of Recreation and Museum's website or by calling (516) 572-8400. The village is open from April through December on weekends and certain weekdays depending on the time of year. There is a ten-dollar adult admission charge or seven dollars for children and seniors.

If you visit on a weekday and can get away from the crowds of schoolchildren to a quiet back fence by the farm or outside of the Manetto Hill Church, it really is possible to let your imagination take you back to life in those times, some 160 years ago.

SAGAMORE HILL

We are accustomed to hearing about Camp David, ranches in Texas and California and presidential retreats in New England, but there was a time when the executive branch of the United States government was run out of

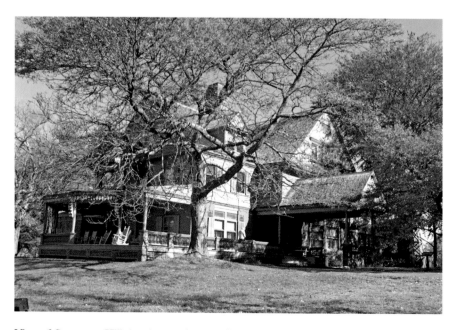

View of Sagamore Hill showing portico over front entrance and side porch. *Photo by author.*

Oyster Bay, Long Island. Theodore Roosevelt was the twenty-sixth president of the United States, having been vice president at the time that President William McKinley was assassinated. He was elevated to the presidency to complete McKinley's term and then went on to win the presidency in his own right in 1904. During his years as president from 1901–1909, his vacation home named Sagamore Hill functioned as a summer White House.

The Roosevelt family had a long history of spending summers in the Oyster Bay area, and so it was only natural for Theodore to choose that area when he was looking for a vacation home of his own. In 1880, he and his fiancée, Alice Hathaway, purchased the hill in Cove Neck where the home presently stands. The property covered a total of 155 acres and only contained an old barn at the time of their purchase. Roosevelt kept 95 acres of the property for himself and his future wife and sold the remaining parcels to relatives. After their marriage, they had an architectural firm draw up house plans, but tragically, Roosevelt's mother and Alice both died on the same day in 1884, before planning had even been completed. Alice had given birth to a daughter also named Alice just two days prior to her passing,

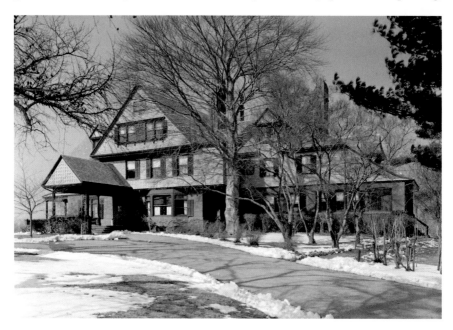

General view of south elevation from the southeast—Sagamore Hill, Oyster Bay, Nassau County, New York. *Courtesy of the Library of Congress.*

and Roosevelt went ahead with plans to have the house built as a home for the new baby.

Roosevelt's career in politics was already well underway, and he divided his time between the house on Long Island and a cattle ranch in North Dakota. His sister Anna moved into the house in 1885 to care for young Alice, and in 1886, Roosevelt remarried and moved into the house with his new bride, Edith Kermit Carow. He originally planned to name the estate Leeholm in memory of his first wife, Alice Lee, but he decided instead to name it Sagamore Hill, after the Indian chief Sagamore Mohannis who had once owned the land.

During the Roosevelt presidency, Sagamore Hill saw guests that included captains of industry, heads of state and dignitaries from all over the world. In 1905, he held meetings there with envoys from Russia and Japan and brokered the peace that ended the war between those two countries. His actions in that regard earned him the Nobel Peace Prize of 1906. On January 6, 1919, Theodore Roosevelt died there in his sleep at the age of

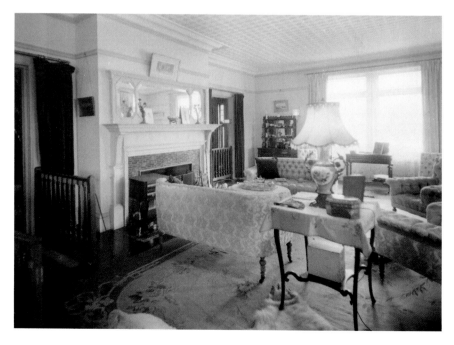

First floor, drawing room—Sagamore Hill, Oyster Bay, Nassau County, New York. *Courtesy of the Library of Congress.*

sixty. The house remains as it was during his life, filled throughout with hunting trophies and memorabilia from his presidency and travels all over the world. His second wife, Edith, continued to live there until her death in 1948. After her death, the house was purchased by a nonprofit corporation dedicated to preserving "T.R.'s" legacy and later presented to the American people as a gift.

Most of the twenty-three-room Victorian home is open to the public by guided tours offered on a "first come, first served basis" for a modest admittance fee. The property is maintained by the National Park Service under the U.S. Department of the Interior, and park ranger guides conduct the tours. They take about an hour and provide a wealth of historic information about the house and Theodore Roosevelt himself. Sadly, the house was closed to the public in December 2011 for a renovation period that is expected to last as long as three years. It is probably the most historic site on Long Island and, when it reopens, should be on the "must-see" list for anyone seeking to learn more about our twenty-sixth president and the history of Long Island.

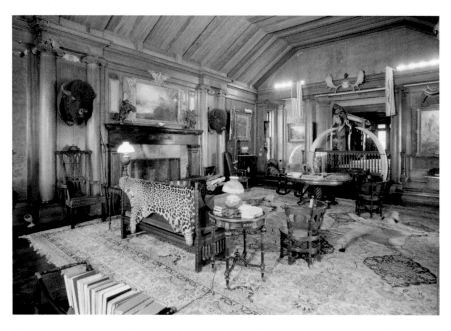

First floor, trophy room, view toward entrance hall—Sagamore Hill, Oyster Bay, Nassau County, New York. *Courtesy of the Library of Congress.*

Coe Hall/Planting Fields Arboretum

The author's visit to Planting Fields Arboretum and Coe Hall came rather late in the process of compiling information for this book. As it turned out, that was a good thing, since this visit might have lessened the experience of visiting so many other interesting historic homes and gardens. Coe Hall and Planting Fields are not just good; they are magnificent.

Beginning in 1904, Helen MacGregor Byrne, the wife of a very successful New York City lawyer, started purchasing farming properties in the area that would become the town of Upper Brookville. There were six properties in all, and she referred to them collectively as Upper Planting Fields Farm. She hired a landscape architect to create hedges, perennial borders, the circular pool and other features that are still prominent on the property today. There is not a great deal of information about the original house that came with the properties, and it unfortunately burned down in 1918.

The entire Byrne estate, with the existing house, was sold to William Robertson Coe in 1913. Coe was born in England and amassed his fortune

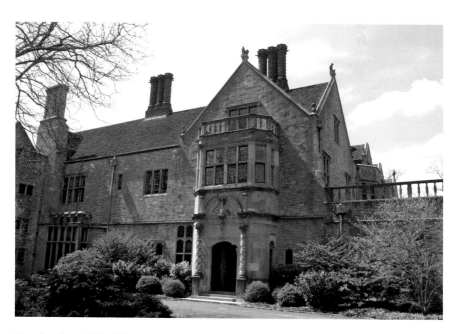

Exterior view of Coe Hall. *Photo by author.*

in the field of maritime insurance. He rose to the position of president of the Johnson and Higgins Insurance Company. In spite of being one of the key figures involved in insuring the RMS *Titanic*, he became chairman of the board of directors in 1916.

After the original house on the property burned down, Coe commissioned the architectural firm of Walker & Gillette to build a new home on the same site. In accord with his English heritage, it was to be built as a sixteenth-century Elizabethan country house, and the construction was completed in 1921. The mansion consisted of sixty-two rooms, and because of Mr. Coe's interest in rare species of trees and plants, the grounds slowly evolved into a botanical marvel.

One of the more interesting additions to the landscaping was the placement of two gigantic beech trees on the property. Mr. Coe's wife, Mary "Mai" Rogers Coe, was the daughter of Henry H. Rogers of Standard Oil Company. She had grown up in Fairhaven, Massachusetts, and the two trees were removed from her childhood home and transported to Upper Brookville. Since they had root balls that were thirty feet in diameter, this involved use of a ferry across Long Island Sound and the widening of roads and removal of utility lines to get them to the Coe property. Sadly, only one survived the journey, and the other died around 2006, but there is a plan to grow new trees from seedlings taken from the original two trees from Fairhaven.

After the death of his wife, Mai, Coe married Caroline Graham Slaughter, who would be his third wife. He enjoyed thoroughbred horse racing, and his horses won a number of prestigious races during the 1920s and 1930s. Six of his horses competed in the Kentucky Derby, but that one prize continued to elude him. One of his horses went on to sire a number of other champions, including the legendary Secretariat. With a number of other homes at his disposal, Coe deeded the Planting Fields estate to the State of New York in 1949. He had already earned a reputation as an extremely generous philanthropist, and this would prove to be one of his more generous gifts. The property by then had grown to 409 acres, and his bequest included all of the buildings on the property and their furnishings. The transfer to the State was to take place upon his death.

William Robertson Coe died of an asthma attack at his home in Palm Beach, Florida, on March 15, 1955. With the designation of the house as

a museum, many of the furnishings, most of which were removed by Coe's heirs, have gradually been returned by family members. Prior to that, during the late 1950s and early 1960s, the estate was used as a college campus by the State University of New York. Today it is an unparalleled example of Gold Coast–era opulence on Long Island.

A day spent visiting the mansion and touring the grounds is an unforgettable experience. The mansion and furnishings are fully accessible, and you can walk around the rooms to get a sense of what daily life was like for William and Mai. There are outdoor gardens and greenhouses full of exotic varieties of plants from all over the world. All of the plants are marked with their species' names, so the gardening enthusiast can get a real education while enjoying a family outing that truly provides something to delight just about every visitor. There is a small admission fee to park on the grounds and an additional charge of $3.50 per person for a guided or self-guided tour of the mansion. Coe Hall and the arboretum were listed in the National Register of Historic Places in 1979.

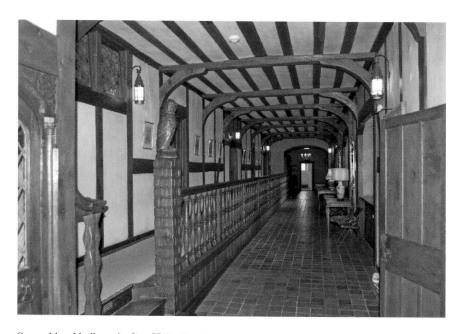

Second-level hallway in Coe Hall. *Photo by author.*

Grumman Aircraft Corporation

At one time, it was the largest employer on Long Island, with a workforce of nearly twenty-three thousand people. Its facilities in Bethpage, Long Island, amounted to six million square feet of manufacturing and warehouse space on a parcel of land that totaled more than 105 acres. While often revered for its contributions to the war effort in World War II and the United States' space program, it is sometimes reviled for the pollution that it left behind. Nevertheless, Grumman Aircraft Corporation occupies an important place in the history of Long Island.

In 1929, when the Loening Aircraft Engineering Corporation of New York City was bought out by another company and moved to Bristol, Pennsylvania, Leroy Grumman and a group of other employees decided to start their own company. They chose to name the company after Grumman because he was the largest investor and filed their corporation papers on December 5, 1929. The business started up on January 2, 1930, at a location in Baldwin, Long Island, and as it grew, it moved to several other locations before finally ending up in Bethpage.

In the early years, the company produced aluminum tubing for truck frames, while pursuing contracts with the U.S. Navy that would ultimately shape its future direction. It designed floats with retractable landing gear built into them that converted navy scouting planes into amphibians and also built a biplane with retractable landing gear that was unique for its time. This relationship with the U.S. Navy expanded during World War II, and the Grumman F4F "Wildcat" and F6F "Hellcat" fighter aircraft became legendary in the annals of aerial combat. In the postwar years, Grumman's A-6 "Intruder" and F-14 "Tomcat" aircraft were important parts of the navy's arsenal.

Throughout the company's history, there were other areas of industry that it pursued, and in addition to aircraft-related parts, it also manufactured canoes and truck and bus bodies. This diversification took an entirely new direction in 1962 when NASA awarded Grumman Aircraft Corporation a contract to build thirteen lunar modules as part of President Kennedy's commitment to land an American on the moon before the Soviet Union could get there. Grumman was the primary contractor on the Apollo Lunar Module that was the key to America's space program and a subcontractor

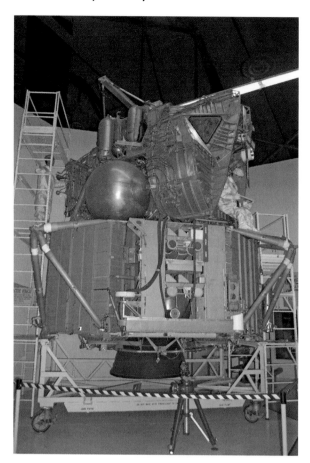

Grumman Lunar Module on display at the Cradle of Aviation Museum. *Photo by author.*

building wings and vertical stabilizer sections for the space shuttles that were being built by Rockwell International.

With this new emphasis on space exploration, the company changed its name to Grumman Aerospace Corporation in 1969 and merged with Northrop Corporation to become Northrop Grumman in 1994. The combined company began moving its manufacturing facilities to other locations, and Northrop Grumman's usage of the original 105 acres has continued to decline as much of the land has been sold to developers. At present, there are multiple housing complexes on land that once held Grumman buildings and a wide variety of businesses that include trucking, warehousing, food distribution and office services. Seven of the original hangars are also being used as movie and television production studios.

There are blue and yellow historic marker signs at several locations that once were part of the original Grumman complex. One of the most significant of these is at the corner of Central Avenue and Grumman Road, which marks the location of the old Plant #1 and a section of the airport runway. A large water tower on the roof of one of the hangar buildings is now marked "Grumman Studios" and can be easily seen from one of the side streets off South Oyster Bay Road. In a sense, this entire part of Bethpage is a historic site that is rapidly being lost to development. People in the area have mixed feelings about having had Grumman as a neighbor because of contamination that has been found in the water table, but some groups, such as the Central Park Historical Society, seem determined to preserve its history. Developers may continue to tear down the old buildings and some memories of Grumman will be lost, but one can only wonder what the world would be like without Grumman's contributions during World War II and its place in America's space program.

JAKOBSON SHIPYARD

Along the shore of Oyster Bay, just off West End Avenue, sits a wonderful waterfront park established by the State Department of Environmental Conservation, in partnership with the Town of Oyster Bay. The sign at the entrance to the park points out that this location was formerly the Jakobson Shipyard, and that gives the park some historical significance.

The company was founded in 1895 by Swedish immigrant Daniel Jakobson, and its first location was in Brooklyn. Its operations moved to Oyster Bay in 1938, and during World War II the company payroll swelled to as many as seven hundred people. The Jakobson yard built a wide variety of different vessels but was primarily known for its tugs, ferries and fireboats. During World War II, production switched over to contracts from the military, and the company began manufacturing minesweepers and rescue tugboats. The rescue tugs were not the smaller harbor tugs that are still in use in every major port in the world but were actually seagoing vessels as long as 165 feet.

Jakobson vessels saw combat duty in both the European and Pacific theaters during World War II. The minesweeper *Exploit*, built in 1942,

Shipyard buildings prior to demolition. *Courtesy of Oyster Bay Historical Society.*

cleared the way for Allied ships during the Iwo Jima and Okinawa landings in 1944. Another minesweeper, *Excel*, also built in 1942, was based in Pearl Harbor and provided convoy escort for the landings at Eniwetok Atoll and Okinawa. The rescue tug *ATR 15* saw service during the Allied landings at Normandy and was lost during the D-Day operation. In the years after the war, the company continued to build tugs and other vessels, including three fireboats for the city of Baltimore and some private yachts.

As overseas competition continued to impact the U.S. shipbuilding industry, the company closed the Oyster Bay operation in 1984. The State of New York bought the property for $5 million in 1997 and turned it over to the Town of Oyster Bay. None of the original buildings are still standing, but the wooden pier jutting out from the park appears to have been part of the original shipyard. There is a large blown-up photograph in the waterfront center's office that shows the original shipyard buildings, and there is a section of track in the park roadway that was a part of the marine railway system used to move medium-sized vessels from the shops and storage buildings down to the water's edge. This site represents another piece of Long Island's history that is being lost, and it is hoped that the Town of Oyster Bay will do even more to preserve the history that was made on the site of the waterfront park.

Part II

SUFFOLK COUNTY

Chapter 4
TOWN OF HUNTINGTON

JOSEPH LLOYD MANOR HOUSE

Most of the colonial-era homes on Long Island are only interesting because they provide a glimpse into what life was like in the seventeenth and eighteenth centuries. While these early settlers did face enormous challenges in carving out lives for themselves in America, there was little to distinguish them from their neighbors. They were simple folk—farmers, merchants, sailors, mill operators, etc.—and were forced to devote all of their time and energy to simply surviving. The Joseph Lloyd Manor House is different in that it was the home of a remarkable man who was not even part of the Lloyd family.

In 1676, a Boston merchant by the name of James Lloyd acquired a piece of land on the north shore of Long Island that was known as Horse Neck. The area was actually known by the Indian name of "Caumsett," which means "place by sharp rock," but the area's farmers preferred their own name for the place where they grazed their horses.

James Lloyd rented out his land to tenant farmers but never relocated to Long Island. His son Henry, however, did give up his shipping business in Rhode Island and moved to his father's land in 1711. Henry built a saltbox-type home on the property, and this has been preserved on the grounds of Caumsett State Park in Lloyd Harbor. It was Henry's son Joseph who built this larger house in 1766, only to have the British appropriate it for use as a local headquarters during the Revolutionary War.

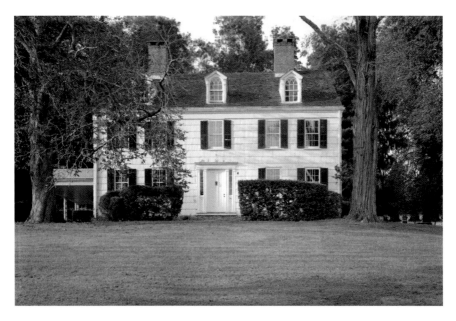

South (front) elevation—Joseph Lloyd Manor House, Lloyd Harbor, Suffolk County, New York. *Courtesy of the Library of Congress.*

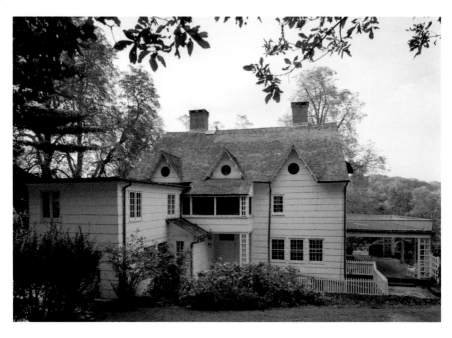

General view of north (rear) elevation—Joseph Lloyd Manor House, Lloyd Harbor, Suffolk County, New York. *Courtesy of the Library of Congress.*

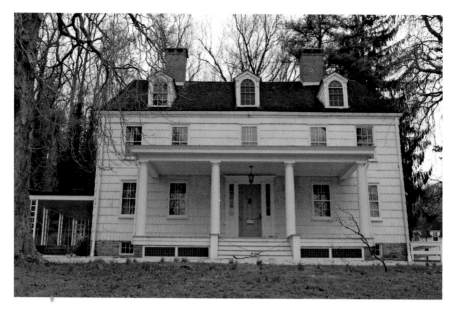

Exterior view of Joseph Lloyd Manor House. *Photo by author.*

In addition to the land passed down to Joseph from his father, he also inherited a slave by the name of Jupiter Hammon. This man was born a slave in 1711 and was owned by four different generations of the Lloyd family. The Lloyds used private tutors to educate their sons and chose to educate Jupiter as well. He became a trusted bookkeeper for the family, whose commercial interests went from the American shores to London and the West Indies. Hammon became interested in the Great Awakening, a religious revival of 1733, and purchased his first Bible from Henry Lloyd. This movement shaped a good deal of his thinking, and in addition to becoming a preacher to the other slaves, he began writing prose and poetry that was religious in nature and filled with biblical imagery.

On Christmas Day 1760, Jupiter Hammon saw his first work published. It was a poem bearing the rather lengthy title "An Evening Thought: Salvation by Christ, with Penitential Cries," and it was written in the style of a Negro spiritual. With this accomplishment, he became America's first published African American poet, all the more remarkable because he lived as a slave for his entire life. He followed this with several years of other writings that generally argued for equality among all people. While Hammon never directly opposed slavery in his writings, he disguised his antislavery protests

with biblical symbols to get the point across. His most famous work was an address given to the Negroes of New York State at a meeting of the African Society, which included the observation, "If we should ever get to Heaven, we shall find nobody to reproach us for being black, or for being slaves." In this address, he stated that he personally had no wish to be free but did want it for others, particularly the young Negroes. No record of Hammon's death was ever recorded, but he is generally believed to have died sometime between 1790 and 1806, leaving behind a rich body of work that is preserved in historical publications.

The Joseph Lloyd Manor House has been maintained by the Society for the Preservation of Long Island Antiquities and lies in the village of Lloyd Harbor, with a beautiful view overlooking the harbor. It is located on Lloyd Harbor Road where it meets Lloyd Lane and is clearly marked as a historic site. The house has been furnished to reflect daily life in 1793 and is open to the public for tours on weekend afternoons from Memorial Day to Columbus Day. More information on the hours and the small admission charge is available on the society's website, www.splia.org. The grounds are beautiful during the summer months, and a tour of the house is unique in that in addition to showing how the owners of the manor lived, it also gives a glimpse into the daily lives of some slaves in colonial times.

WALT WHITMAN'S BIRTHPLACE

One of the most upscale and successful shopping centers on Long Island is the Walt Whitman Mall, located on Route 110 in Huntington Station. It is named for the nineteenth-century American poet and essayist who is often referred to as the father of free verse and who was one of the most influential poets in American history. His writings were regarded as very controversial during his time, and they frequently challenged social conditions and nineteenth-century views on sexuality.

Walt Whitman was born on May 31, 1819, in a house built in 1816 by his father, Walter Whitman. The house sits just south of the mall and is located, appropriately, on Old Walt Whitman Road. It is maintained in its original condition by a nonprofit association and is listed on the National Register of Historic Places. At the time of the home's construction, Long

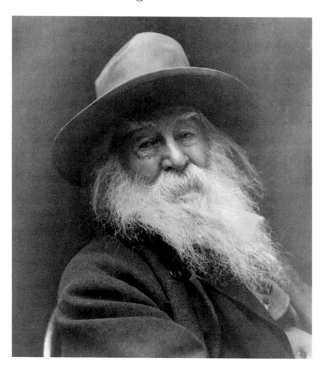

Walt Whitman. *Courtesy of the Library of Congress.*

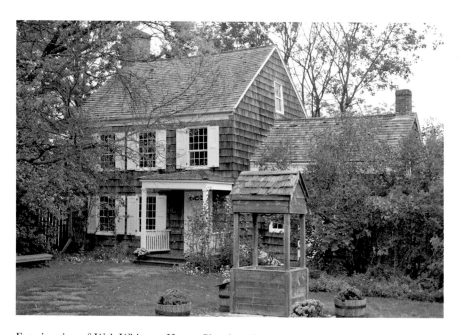

Exterior view of Walt Whitman Home. *Photo by author.*

Island was still known by its Native American name, "Paumanok," which is the Algonquin word for fish.

The house is constructed of hand-hewn beams connected by wooden pegs and sits on a foundation of whole tree trunks and small boulders. The elder Mr. Whitman incorporated a number of unusual features in the house and hoped to show it to prospective customers as an example of his work so that he could sell additional homes. It features closets built into the walls in several rooms and larger-than-usual windows to create a more airy and well-lit environment. Walking up the stairs to the second-floor bedrooms is an unusual experience—as the visitor gets closer to the second floor, the height of each step continually decreases. It is thought that this made the process of descending the stairs at night in limited lighting a bit safer.

The Walt Whitman Birthplace Association has furnished the house with authentic pieces from the early nineteenth century, so only organized guided tours of the building are allowed. In the adjacent Interpretive Center, there are numerous examples of Whitman's work, including original letters and manuscripts. Included in these are first editions of his famous book of poetry entitled *Leaves of Grass* and an autobiography that he chose to name *Specimen*

A main room that doubled as a bedroom in the Walt Whitman Home. *Photo by author.*

Days. The center also has on display a writing desk used by Whitman during his tenure as a young schoolteacher on Long Island (1836–38).

To reach this historic home, head a few blocks south of the mall, where Old Walt Whitman Road splits off to the right. There are historic marker signs on Route 110, and the home is open seven days a week from June 15 to Labor Day. The winter hours are more limited, and you can check the schedule on their website at www.waltwhitman.org. There is a five-dollar admission charge for adults and four dollars for children and seniors. Walt, whose nature was generally described as "transcendental," would probably not have approved of the emphasis on material goods that characterizes the shopping mall that stands a few blocks from his birthplace and bears his name.

COLD SPRING HARBOR FISH HATCHERY

In addition to providing an enjoyable day outing for families, with many activities geared for children, this Long Island landmark offers an interesting bit of history as well. The entire surrounding area was named "Cold Spring" back in 1650 because of the numerous freshwater springs running through it. Its history goes back to an early English settlement that was established on land owned by the Matinecock Indian tribe. The buildings that house the hatchery offices and aquarium were originally part of a wool mill and were donated to New York State by a family named Jones.

New York State's first attempt to grow fish in a controlled environment dates back to 1870. That first hatchery was located upstate near Rochester, but it did not succeed because environmental conditions were not ideal. A second attempt was made at Roslyn, Long Island, without much success, and the final site chosen was the one located in Cold Spring Harbor, which was established in 1883. The site where the hatchery now resides is continually fed with water from artesian wells, which generally force water to the surface without a great deal of pumping. The water maintains a constant temperature of fifty-two degrees Fahrenheit, which has proven to be ideal for breeding the species on display in the eight outdoor ponds.

In 1982, the hatchery was closed as a state facility but reopened the following day as a nonprofit educational center. An aquarium was added that presently houses the largest known collection of freshwater reptiles,

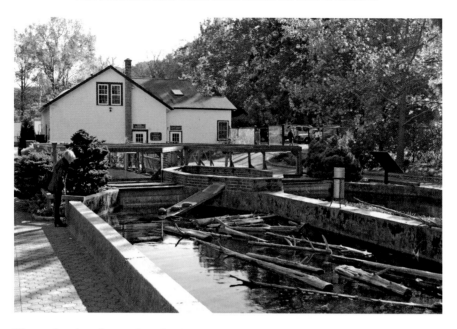

The outdoor breeding pools and main building at the Cold Spring Harbor Fish Hatchery. *Photo by author.*

fish and amphibians that are found in New York State. There are enough different animals on display to astound young visitors, and there are special children's and seasonal programs to provide year-round entertainment and educational opportunities. It is located right on Route 25A just west of the village center, and the modest admission fees collected are used to support the hatchery's development and educational programs. Dangling a line in one of the fully stocked outdoor pools is a wonderful first fishing experience for young children and can easily bring a smile to the faces of older visitors who may be young at heart as well.

COLD SPRING HARBOR LABORATORY

For anyone with even a passing interest in science, the Cold Spring Harbor Laboratory is a must-see stop on any visit to Long Island. The campus sits on a beautiful one-hundred-acre parcel of land, donated in 1889 by John D. Jones. Mr. Jones also included some early buildings that had been part of the Cold Spring Harbor Whaling Company in his generous gift.

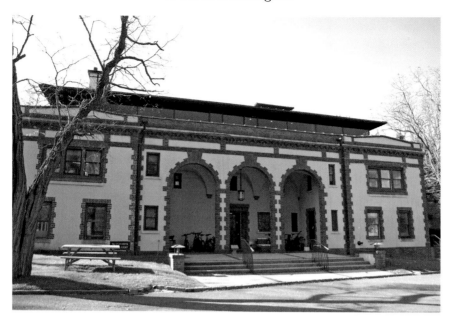

McClintock Laboratory at the Cold Spring Harbor Laboratory. *Photo by author.*

Founded as a laboratory for training high school and college teachers in marine biology, the facility was originally part of the Brooklyn Institute of Arts and Sciences. The location was thought to be ideal because of its proximity to the harbor and waters of Long Island Sound. Courses began in 1890 and initially focused on the more general study of biology. By 1904, the lab's mission had expanded to the area of genetics research, in affiliation with the Carnegie Institute of Washington. Charles Davenport, a professor of evolutionary biology at Harvard, was appointed director, and work began in areas pioneered thirty-five years earlier by the noted scientist Gregor Mendel.

In 1910, a government agency known as the Eugenics Record Office was established at Cold Spring Harbor, and its work created some controversy during the 1930s. The data produced by its studies was used to limit the number of immigrants from certain European countries, as well as support the sterilization of mentally ill and learning-impaired people. These studies were later discredited, and much of the work was perceived as being in sympathy with what the Nazis were doing in Germany to breed a so-called Master Race.

Early research into finding a cure for cancer began in the 1920s, and that work continues to this day and is a primary focus of the lab's research. During World War II, research at the lab by Milislav Demerec improved the strains of penicillin that were so important to treating injuries and disease during the conflict. In later years, beginning around 1950, an emphasis on genetic research led to the discovery of the structure of the DNA double helix by James Watson in 1953. By 1962, with the end of the support of the Carnegie Institute, the Department of Genetics merged with the Biological Laboratory to form the Cold Spring Harbor Laboratory as we know it today. Work conducted at the lab has resulted in the awarding of eight Nobel Prizes for discoveries made there, and its present mission runs the gamut from finding the cure for various cancers to improving the quality of the humble tomato.

Guided tours of the lab and grounds are conducted by researchers working there and provide a wealth of information about its history and the important work being done at this time. There is a modest five-dollar charge for the tours, which last about two hours and can be arranged by calling the Public Affairs office at (516) 367-8455. The tours include a discussion of the

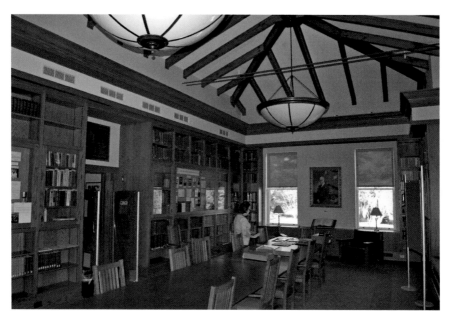

Carnegie Library at the Cold Spring Harbor Laboratory. *Photo by author.*

early years when visiting scientists came in the summer months and camped in tents while they conducted their research, as well as visits to some of the historic buildings. A visit there is a wonderful way to experience some history and learn about the amazing work that is being done to improve the world that we live in today.

Eagle's Nest—Vanderbilt Mansion

Long Island's village of Centerport is home to a forty-three-acre property that provides something to interest just about everyone in the average American family. Visitors can enjoy a Gold Coast mansion, maritime museum, planetarium, beautiful gardens and spectacular water views, and they all bear the name of one of the most famous families in high society: Vanderbilt.

William K. Vanderbilt was born on March 2, 1878, in New York City. He was born into a family that had enjoyed great wealth for several generations and was the first son of William Kissam Vanderbilt and Alva Murray Smith. "Willie K.," as he was known, grew up in family mansions and spent many of his early years sailing all over the world on yachts owned by his father. At one time, the Vanderbilts were the richest family in the United States, so it was only natural that Willie enjoyed a life of leisure and luxury. When he was twenty years old, he met a woman named Virginia Graham Fair, known affectionately as "Birdie," and married her in 1899.

Willie K. was an accomplished sailor and yachtsman, as well as an early motor racing enthusiast. His passion for automobile racing prompted him to sponsor the early races on Long Island that awarded the Vanderbilt Cup and later to lead a group that built the Long Island Motor Parkway (commonly referred to as the Vanderbilt Motor Parkway). One can only wonder what life was like for the young couple, with Willie away much of the time pursuing one of his adventurous hobbies. After ten years of marriage, he and Birdie separated, and he began work on a home on Long Island that he would describe as a "modest bachelor's retreat."

The name that Willie chose for this home was Eagle's Nest, long before Adolph Hitler would use the name for his own summer getaway in the Alps. It was described as being of Spanish Revisionist architecture and was set on

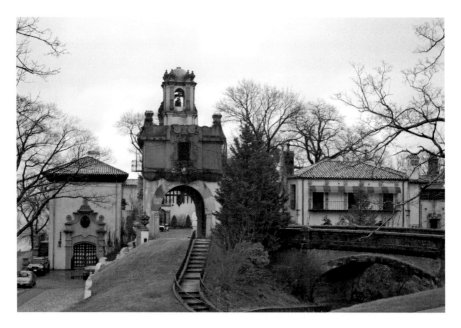

Main residence at the Vanderbilt Estate. *Photo by author.*

property somewhat distant from the Gold Coast mansions that were springing up all across Long Island's North Shore. Willie ensured that it had access to Northport Harbor to accommodate his passion for boating. The original house built in 1910 was, by Willie's standards, a modest bungalow with a boathouse. Over the years, it evolved into the twenty-four-room mansion that it is today. By most accounts, it was his memories of voyages through the Mediterranean that made him prefer the Spanish style, which was a rarity on Long Island at that time. His interest in marine biology, cultivated during those voyages, inspired him to choose fossil-encrusted limestone for the building blocks used in the construction. The wooden doors located throughout the mansion came from castles and mansions all over Europe, and the fifty-four thousand cobblestones used in the driveways and grounds were reclaimed from a construction project in Greenwich Village.

Willie and Birdie finally divorced in 1927, and he married his second wife, Rosamund Lancaster Warburton of Philadelphia. Eagle's Nest became one of the many summer homes used by the couple, and the estate continued to be modified to meet the needs of a family rather than as a bachelor's retreat. In 1933, a tragedy that struck the family was the impetus for another addition

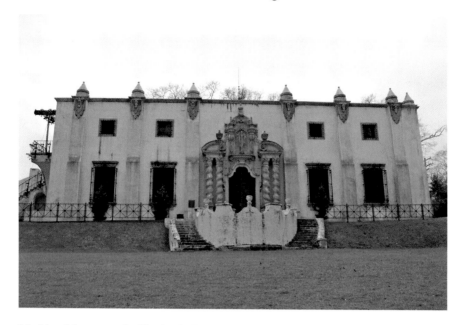

Maritime Museum at the Vanderbilt Estate. *Photo by author.*

to the mansion. Willie's twenty-six-year-old son from his first marriage was killed in an automobile accident. That son, William Kissam Vanderbilt III, had inherited his father's love of exotic travel and had accumulated trophies and souvenirs from years of African safaris. Willie K. built a new wing on to the mansion to house his son's collection, and this is still available for viewing on the guided tours that are conducted through the house

Today the entire property is maintained as a Suffolk County museum and is open to the public for tours and private events. There are automobile exhibitions on the property in keeping with Willie's love of fast cars, and the Maritime Museum houses one of the largest privately owned collections of marine life specimens in the world. The grounds and views of Northport Harbor give some insight into the life of William K. Vanderbilt II, but it is the mansion that holds the key to who he really was. Take the guided tour to see all of the original mansion furnishings, the hand-carved ceiling in the dining room and the little alcove where Willie and Rosamund took breakfast every morning. The guides provide wonderful anecdotes about Willie, and looking out from the mansion over Northport Harbor gives visitors a glimpse into what life was like during Long Island's Golden Age.

OHEKA CASTLE

The year was 1917, and the United States was expanding its influence in the Caribbean region by purchasing the Virgin Islands from Denmark and allowing Puerto Rico to become a U.S. territory. Across the Atlantic Ocean, Europe was in turmoil. The Russian Revolution was taking place and overthrowing the Czarist monarchy, while Germany was using submarine warfare to dominate the seas and sink commercial shipping. On February 3, Germany sank the U.S. liner *Housatonic*, thereby plunging the United States into World War I. Seemingly untouched by all of this, the noted investment banker and financier Otto Kahn was beginning construction of what would become the second-largest private residence ever built in the United States.

Otto Hermann Kahn was born on February 21, 1867, in Mannheim, Germany, to Jewish parents. His ambition was to become a musician, but his father had other plans in mind for him and set him on the road to becoming a banker. He enjoyed early success in his banking career and moved on to even greater achievements by relocating to England. In 1893, he accepted an offer from his father-in-law, who was a successful financier in the United States, and relocated to New York City. He was known for his ability to reorganize troubled railroads, and as his reputation grew, so did his net worth. In 1917, he gave up his British citizenship and became a U.S. citizen. It was around this time that he began construction of what would later be known as Oheka Castle.

Kahn had purchased a 443-acre plot of land in Cold Spring Harbor and began having fill materials brought to the property to build a hill and make it the highest point on Long Island. The huge French-style chateau was completed in 1919 and contained 127 rooms. Its cost at that time was $11 million, which would amount to about $110 million in today's currency. He named it simply Oheka, which was derived from the first letters of his three names, and during the 1920s, he hosted lavish parties and entertained royalty, heads of state and Hollywood movie stars.

After Kahn's death in 1934, ownership of the estate changed several times, and at one time, it served as a retirement home for New York City sanitation workers. It was later used as a training school for Merchant Marine radio operators, and in 1948, it was purchased by the Eastern Military Academy. The academy made numerous modifications to the original construction to

allow it to function more efficiently as a school, but it went bankrupt in 1979 and the property was abandoned. In 1984, a Long Island developer purchased the estate, which now occupied only twenty-three acres, and began a complete restoration. That work continues to the present time, with about 70 percent of the property now restored (as of 2009).

Oheka Castle is currently listed on the National Register of Historic Places and can be hired out for conventions, weddings or any private affair requiring this level of elegance. It offers thirty-two guest rooms, an eighteen-hole golf course, fine dining, tennis and historic tours of the mansion. The entrance to the property is well marked by a stone gateway right on Route 25A, just east of Cold Spring Harbor, but keep in mind that this is a commercial property and not a museum where visitors can just walk in off the street and browse around. If you are able to tour the property, you will find that it is one of the finest examples of Long Island's Gold Coast mansion–era to be found.

Chapter 5

TOWN OF BABYLON

FIRE ISLAND LIGHTHOUSE

Since it is an area with such a rich maritime tradition, it is no surprise that Long Island is heavily dotted with lighthouses. Though not as old as the Montauk Light, the Fire Island Lighthouse is still one of the oldest facilities of its kind on Long Island and was a vital aid to navigation for many years.

The first lighthouse built on Fire Island was completed in 1826. It was constructed of Connecticut River blue stone but was only seventy-four feet high. After several years of service, it was found to be ineffective due to its limited height and was taken down to be replaced by a higher tower. Most of the stone from the original facility was used to build the terrace for the present lighthouse, and all that remains at the original site is a circular ring of brick and stone. Because of erosion and the movement of sand by tidal forces, the site chosen for the new lighthouse was approximately six miles west of the original location.

In 1857, Congress appropriated the sum of $40,000 for construction of the new tower. It was made of red brick painted a creamy yellow color and was 168 feet tall. The new light was first turned on in November 1858, and in 1891, the paint scheme was changed to the alternating black and white bands that are still in evidence today. At the beginning of the twentieth century, the Fire Island Light was the first sign of America seen by European immigrants as their ships passed by on the way to New York harbor.

View of the Fire Island Lighthouse from the access road. *Photo by author.*

Though originally lit by lamps burning whale oil, mineral oil, lard oil or kerosene, a switch over to an electric lamp was scheduled for September 20, 1938. Unfortunately, the area was hit by a hurricane the following day, severing all electric power and delaying the conversion to an electric light. Like all other lighthouses of that time, the maintenance and operation of the facility was handled by the United States Lighthouse Service. Since there had been a Coast Guard facility on Fire Island since 1915, when the Lighthouse Service was dissolved, responsibility for the light fell to the United States Coast Guard. It continued to man the light until 1973, when the lighthouse was decommissioned on December 31. It was replaced by a more modern navigational light that was installed on top of the Robert Moses State Park water tower.

The Coast Guard issued a permit to allow use of the lighthouse property by the National Park Service, and public support, along with a "Save the Fire Island Lighthouse" movement, resulted in its preservation and addition to the National Register of Historic Places. It is presently maintained and operated as a private aid to navigation by the Fire Island Lighthouse Preservation Society. Today it is lit by two one-thousand-watt bulbs that produce a light that is visible for twenty-one to twenty-four miles, depending on weather conditions. It is open to the general public every day during the summer and on weekends for the remaining three seasons. Parking is at Field #5 in the Robert Moses State Park, and a short walk over a wooden covered walkway will bring visitors to the lighthouse and a chance to visit this historical building. The walk from the parking field also offers an opportunity to view the local ecosystem and possibly encounter one of the many deer that inhabit the area.

FAIRCHILD REPUBLIC AVIATION

One of the most important elements in Long Island's rich aviation history is the Fairchild Republic Aviation Company that was located in Farmingdale. The company was founded in 1924 by Sherman Fairchild as the Fairchild Aviation Corporation. The Farmingdale facility served as the headquarters for a wide variety of aviation and aviation-related companies until the main office was moved to Hagerstown, Maryland, in 1931. Long Island continued to be a manufacturing facility and played a vital role in American airpower through three different wars.

Prior to World War II, a number of different Army Air Corps training aircraft were produced at Farmingdale to help America gear up for the conflict ahead. Many of America's fighter pilots took to the skies in the more than nine thousand P-47 Thunderbolts that came out of the Long Island factory. It also produced components for the famed C-82 cargo aircraft during World War II that later evolved into the C-119 transport commonly known as the "Flying Boxcar." The "Flying Boxcars" proved to be the perfect aircraft to be converted to water tankers, and some of them are still in use today, fighting forest fires in our western and southwestern states.

During the Korean War, Fairchild Republic's F-84 fighter jet became the primary strike aircraft for U.S. forces, flying more than eighty-six thousand missions and becoming the first aircraft used by the U.S. Air Force Thunderbird precision flying team. The early stages of the Vietnam War saw the U.S. military relying on the F-105 fighter bomber for more than twenty thousand missions, before it was pulled from combat duty due to excessive losses. In later years, Farmingdale produced wing and structural sections for the Boeing 747 and 757 commercial jets and components for the company's A-10 Thunderbolt (named after the World War II fighter) that was being manufactured in the Hagerstown, Maryland factory.

As a result of the takeover of Republic Aviation, which had its own facilities, the Farmingdale factory complex was closed in 1987, and the land was used to construct the Airport Plaza Mall, on Route 110 adjacent to Conklin Street. Some of the original buildings still stand on the east side of Conklin Street near Route 110, but they are in disrepair and will probably be demolished. The Republic Airport terminal building located near the control tower houses a photo exhibit commemorating the history of Fairchild Republic's place in aviation history. One of the tenants in the Airport Plaza Mall is a

Abandoned Fairchild buildings on the west side of Conklin Street. *Photo by author.*

restaurant and game room facility that is part of the Dave and Buster's chain of restaurants. The game room features a variety of military-oriented video games, some of which feature aircraft that were manufactured by Fairchild Republic Aviation. Youthful game players would be surprised to learn that many of the aircraft they are seeing on the video displays were manufactured on the ground that lies right beneath their feet.

NIKE MISSILE SITE

One of the characteristics of the Cold War era after World War II was the establishment of an elaborate air defense system throughout the United States. It was felt that the Soviet Union presented a credible threat to the nation's security and that multiple lines of defense would be required to counter a first strike attack by Soviet aircraft. In addition to interceptor aircraft and long-range missiles, a final line of defense was required, and so in 1945 Bell Telephone Laboratories developed the concept of a shorter-range missile to protect likely target areas.

Named after the Greek goddess of victory, the Nike missile was to be the last resort to counter a Soviet air attack. It was a land-guided short-range missile that could be directed from the ground by radar and a computer guidance system and would destroy a Soviet bomber regardless of the evasive actions attempted by its pilot. The government built hundreds of Nike missile sites all across the country, with more than twenty in the New York area alone. One of the New York sites was designated Nike Battery NY-24, and it was located in a part of South Farmingdale that is now an industrial park.

The typical Nike missile site required two separate parcels of land, at least three thousand meters apart. There was something in the technology at that time that required that the command and control facility be at least that distance from the launching site. The missiles were stored underground and were brought to the surface by an elevator system so that they could be pushed along a series of rails to the actual launcher. Once launched, they would travel at several times the speed of sound (from 1,600 miles per hour to 2,700 miles per hour on later models) and were to strike incoming aircraft that were relatively close to the general target area. They carried

A Nike missile on display at the Airpower Museum in Farmingdale. *Photo by author.*

a variety of conventional warheads but were rumored in later years to be armed with nuclear weapons. The government would never admit to this change in armament, because the Nike missiles were launched from what were frequently residential areas.

Deployment of the Nike systems began in the early 1950s, and they were phased out in the 1960s as it became apparent that the Soviet Union was relying more on intercontinental ballistic missiles than its aging fleet of bombers. The last sites were decommissioned in 1974, but the army retained ownership of many of the land parcels, and the one in South Farmingdale is still in use today as a U.S. Army Reserve Center. It is easily found by heading south on Route 110 past Route 109, making a left turn on to Allen Boulevard and then the first right turn onto Baiting Place Road. There are no remaining traces of the property having once been a missile site, but it is unmistakably an army installation with a large fenced yard full of military vehicles.

People often say that it was a different time then and different rules applied, but one has to wonder what the outcry would be today if it were found that there were nuclear tipped missiles less than a mile from a school and in a residential neighborhood.

Chapter 6
Town of Islip

Sagtikos Manor

The often-stated claim that "George Washington slept here" is frequently used to give some historical significance to an old building, but at one of Long Island's old homes, this claim is much more than just a sign on the lawn. Construction of Sagtikos Manor, located in West Bay Shore, was begun in 1697, long before George Washington was even born. The name "Sagtikos" comes from a Native American word meaning "head of the hissing snake" and relates to the sound of a small stream that flows through the property. Sections of what is now the Sagtikos Parkway were once a private road built mostly for access to the original manor property.

The land was purchased from the local Secatogue tribe in 1692 by Stephanus Van Cortlandt. It remained in his possession until his death in 1700 and was then sold to Timothy Carll in 1706. The Carll family added additional property to the estate, which grew to a total of 1,200 acres by the time that it was sold to Johnathon Thompson, of Setauket, in 1758. Jonathon's son Isaac married Mary Gardiner and more than doubled the size of the original house. Members of the Gardiner family continued to occupy the home until 1985, after which it was deeded to a foundation that later sold it to Suffolk County.

In 1790, as George Washington conducted a tour of Long Island, he recorded in his diary that he spent an overnight stop at Sagtikos Manor. While General Washington may have enjoyed a stopover at "Squire Thompson's" home after the war had been won, for a time during the actual Revolution,

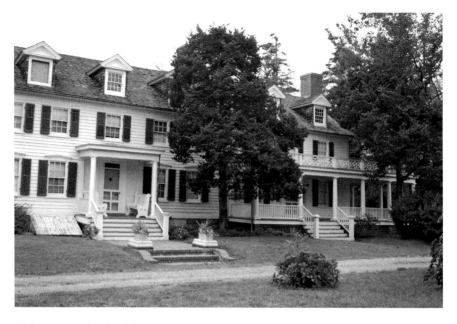

Main house at Sagtikos Manor (note two separate front entrances). *Photo by author.*

the house served as the local headquarters for British forces commanded by General Sir Henry Clinton. Also on the property are a carriage house, caretaker's cottage, buttery, potting shed, formal gardens and the Thompson-Gardiner family cemetery.

Sagtikos Manor is located on Montauk Highway, Route 27A in West Bay Shore and is open to the public from Memorial Day through Labor Day. Adult entrance fees are seven dollars, with reduced rates for seniors, students and children under twelve. The entire property provides a fascinating look into life in colonial times, further enhanced by guided tours of the manor by volunteers outfitted in period dress. The manor was honored by being added to the National Register of Historic Places in 1976.

St. Mark's Episcopal Church

One of the most striking groups of buildings on the south shore of Suffolk County is the St. Mark's Episcopal Church complex located on Montauk Highway (Route 27A), just east of Route 111. Built in 1847 in what is

described as the "Norwegian Stave Design," the complex consists of a house of worship connected by a covered walkway to a school and rectory house. The church is located in the town of Islip, which is named after a town in Northamptonshire, England, that dates back to the sixteenth century.

Seventeenth-century England was characterized by widespread opposition to the practices of the Church of England, and large numbers of dissenters fled to the New World to seek religious freedom. Typically, the trip to America would involve a temporary stay in the Netherlands before embarking to settlements like the Massachusetts Bay Colony. In time, this immigration eventually led to settlers crossing Long Island Sound and establishing new communities on Long Island.

During a time of worsening relations between the English and the Dutch, Charles II of England aggravated the situation by granting his brother James, the Duke of York, land that was actually part of a Dutch colony called New Netherland. The colony was at the mouth of the Hudson River, and it would require a British naval victory to enforce England's claim to the territory. In 1664, in an effort to strengthen his claim, James mounted an

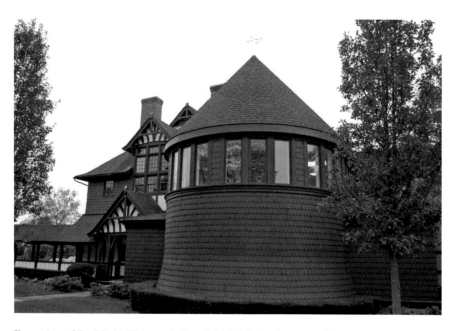

Front view of St. Mark's Episcopal Church highlighting the unusual tower structure. *Photo by author.*

expedition to the New World and appointed Matthias Nicoll II to serve as its secretary. Matthias had lived in the English community named Islip, and it was his son William Nicoll who began accumulating land on Long Island from the local Secatogue Indian tribe in 1683. Eventually, William's holdings increased to fifty thousand acres (nearly ten square miles) covering the area from Bayport to East Islip and everything in between.

In 1704, the rector of Trinity Church in New York realized that there was no representation for the Church of England in all of Suffolk County and began sending ministers to Long Island to establish the church there. By 1730, the present Episcopal church in Setauket had been built, and early churches appeared in Huntington, Oakdale and Islip, though the Islip church was destroyed by fire in the early 1800s. The cornerstone of the present St. Mark's Church shows that it was rebuilt on July 4, 1847, which shows amazing durability for the type of wood construction used at the time.

The contrasting dark wood and white sections of the buildings, coupled with magnificent stained-glass windows, provide a wonderful photo opportunity to record colonial history and the uniqueness of these buildings. What is all the more remarkable is that census records of that time list barely enough people to fill a church this size for a normal Sunday service.

Westbrook Estate

Located along the east side of the Connetequot River is a sixty-eight-room mansion that is one of the few remaining examples of Gold Coast–era estates on the South Shore of Long Island. Formerly known as Westbrook, it is now part of the Bayard Cutting Arboretum property, which consists of hundreds of acres of natural scenery punctuated by walking trails. The mansion is a Tudor-style home dating back to 1886.

William Bayard Cutting purchased an area of more than nine hundred acres from Pierre Lorillard in 1880 and began construction of a home several years later. He had amassed his fortune in the sugar beet industry and also built railroads and a ferry business along the New York City waterfront. Mr. Cutting was a sportsman and nature lover with a particular interest in gardening, and so he hired the noted landscape architect Frederick Olmsted to lay out the surrounding property and bring in plants and trees from all

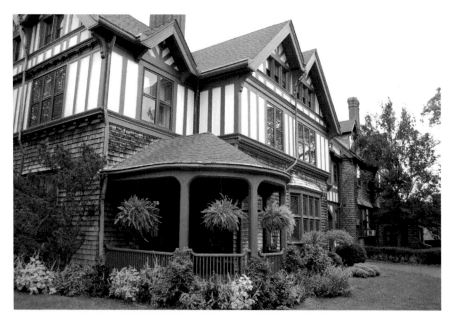

Left front corner view of the Bayard-Cutting mansion. *Photo by author.*

over the world. In 1895, Mr. Cutting and his brother also laid out a golf course on the property, making it the first private golf course in the United States.

Upon his passing in 1912, the house and approximately two hundred acres of the surrounding property were given to the people of Long Island by Mr. Cutting's widow and daughter, for use by the general public as an "oasis of beauty and quiet." In 1938, Mr. Cutting's daughter donated additional property to bring the arboretum up to its present size of nearly six hundred acres. The manor house is a spectacular example of the Queen Anne style and is mostly furnished as it was at the time of its use by the family. It features dark carved wood in many rooms, a massive fireplace at the entrance and delightful stained-glass windows throughout. As an excellent example of homes from this period, it was featured in the 1993 film *The Age of Innocence*, starring Daniel Day Lewis, Winona Ryder, Michelle Pfeiffer and Joanne Woodward.

When strolling the grounds, one is immediately struck by the fact that there are no formal gardens that are mostly in evidence at other estates from this era. This is a testament to Mr. Cutting's love of nature and desire

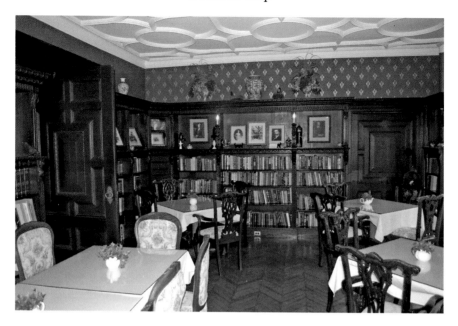

The library at Westbrook, set for afternoon tea. *Photo by author.*

to keep the grounds in as pristine and natural condition as possible. The property is managed by the Long Island State Park Commission and is open to the public Wednesday through Sunday, for a minimal admission charge. It was named to the National Register of Historic Places in 1973 and offers a chance to view local wildlife, beautiful landscaping overlooking the river and a beech tree that is so large that it has benches within it for visitors to sit on.

THE HOME OF "SCRABBLE"

If you happen to have an old Scrabble game tucked away in a closet or stored in the attic, you have a link to the history of Long Island that you may not have been aware of.

The game of Scrabble was invented by an out-of-work architect named Alfred Mosher Butts in Poughkeepsie, New York. It was first named Lexiko and then later changed to Criss Cross Words, but Butts was unable to interest any established manufacturers in developing the game for him. It was not until he met with a game-loving entrepreneur named James Brunot in 1948

that he changed the name to Scrabble and began manufacturing it in an abandoned schoolhouse in Connecticut. The two partners were able to turn out a meager twelve games per hour and lost money for four years, even though the popularity of the game continued to grow.

In the early 1950s, the president of the Macy's department store chain discovered the game while on vacation and began ordering it for his stores. Within a year, the fledgling company could no longer keep up with the demand for the game, and in 1952, it licensed Long Island–based Selchow & Righter, Inc. to produce and market the game. This company was founded in 1867 by E.G. Selchow and had achieved its first success with the game Parcheesi, which it began producing in 1870. To keep up with the steadily increasing demand for Scrabble, the company, which had its roots in Bay Shore back to the late nineteenth century, built a new plant at 2215 Union Boulevard in 1955. Selchow & Righter continued to manufacture Scrabble, Parcheesi and a variety of other games at this Bay Shore location until it was purchased by Coleco Industries in 1986.

Front entrance to the 1955 Selchow & Righter factory building in present times. *Photo by author.*

This 1955 building is still standing, located just south of Sunrise Highway and east of Brentwood Road. It is presently occupied by a powder coating company and a packaging and distribution provider, both of whose names begin with the letter "T." If you do not factor in double/triple word or letter bonuses, the two company names have Scrabble letter values of 13 and 8, respectively.

Chapter 7
TOWN OF SMITHTOWN

STONY BROOK GRIST MILL

Situated in the heart of the historic village of Stony Brook is Long Island's oldest complete working gristmill. A gristmill uses water power to drive a huge stone wheel that grinds corn or grain against an equal weight fixed-bottom stone. In this case, the water flows from the adjacent millpond into a sluice on the side of the mill and then over the wooden wheel that drives the gears connected to it.

The original mill on this site dated back to 1699 but was washed away in later years by a flood. The current mill was built in 1751 by a man named Adam Smith, but over the years the mill has had more than two dozen different owners. Local farmers would bring their grain to the mill to be ground into flour, and small ships would sail up from Stony Brook Harbor to grind their corn and grain as well. The person who owned the mill would get a payment of one-tenth of the grain being ground, which would make the miller one of the more affluent members of most colonial communities.

It is hard for us today to imagine that something as mundane as a mill would also function as the center of community life, but this was the case with the Stony Brook Grist Mill. The mill brought all of the local people together, and it was traditional for them to exchange news and gossip while they waited for the miller to complete his job. When you add in the crews of ships coming from outside of the immediate area, it is easy to imagine socialization at the mill being an exciting part of daily life in colonial Long

View of Stony Brook Grist Mill from the pond across the street. *Photo by author.*

Island. Over the years, parts of the mill building also served as a cabinet shop and even a winery, as its owners sought to capitalize on the fact that so many people made their trips to the mill an important part of their lives. By the nineteenth century, entertainment had been added to the experience, and artists such as violinist and women's right-to-vote advocate Alois Kopriva performed gypsy music at the mill, to the delight of the local residents.

The Stony Brook Grist Mill continued to operate up until the 1940s, with Frank Schaefer being its last owner of record. In 1947, it was purchased by the philanthropist Ward Melville, who later deeded it to the Ward Melville Heritage Organization. It continues to operate the mill as a historic site to this date. It is listed on the National Register of Historic Places and is open to the public for tours on weekends from May through October. The adjacent millpond is quite scenic, and the entire village atmosphere, with its museums and factory outlet stores, makes the area a worthwhile day trip for local residents and visitors alike. It is a wonderful destination for school trips or anyone with an interest in history and a desire to experience a piece of colonial life on Long Island.

ST. JAMES GENERAL STORE

There is hardly a better place to experience what it was like to live on Long Island in the nineteenth century than the St. James General Store. An early settler named Ebenezer Smith built the store in 1857, and the Smith family continued to operate the store for more than one hundred years.

Legend has it that Ebenezer Smith's father, Richard, made a deal with the Nesaquake Indians to purchase a large parcel of land that would be defined by the area that he could encircle in one day while riding his pet bull. That area became what is today the Township of Smithtown, and the small hamlet that became St. James was known at that time as Sherawogge. Ebenezer, however, desired to seek his fame and fortune elsewhere, and in the early 1840s, he packed up an assortment of goods and left on horseback to trade with the settlers and Indians in the Mississippi River Valley. News of the gold strike in California caused Ebenezer to venture even farther west, but he would eventually return to Long Island.

By the time he returned to Long Island, the little hamlet of Sherawogge had changed its name to St. James, in honor of the local Episcopal church. Ebenezer built the store that still stands today and saw it become the hub of a community of about thirty homes. The store sold pretty much everything that local farmers of the 1860s would need. Its merchandise included yard goods, kitchen wares, medicine, shoes, tobacco, groceries, hardware and more. When the first post office was established for the growing community of St. James, it also was located within the general store. Residents would gather at the store to shop, wait for mail and engage in all sorts of conversations, including the local gossip.

In addition to farming, many local families made their livings by cutting cordwood or by harvesting the local shellfish, both of which were then shipped through Stony Brook Harbor on schooners bound for New York City. New York at that time had an excess of horse manure, so on the return trip, the schooners would carry this for use as fertilizer on the local farms. In 1873, the railroad was extended to St. James, which initially brought fears that the land would be bought up by speculators. This never happened, and by the early 1900s, what the railroad did bring was celebrities who found St. James ideal for their summer getaways. Names such as Ethel and Lionel Barrymore, Buster Keaton, Myrna Loy, Irving Berlin and heavyweight

St. James General Store. *Photo by author.*

boxing champion "Gentleman" Jim Corbett can all be found in the register of the old general store.

In the years that followed, the store would pass out of the hands of the Smith family and see a number of different proprietors. The families of Andrew Havrisko and John Oakley both saw the need to preserve the store as a historical site, and in 1990, they sold it to the Suffolk County Parks Department, which operates it today. It has been maintained as it was during the period from 1880 to 1910 and contains the original counters, display cases, potbellied stove and even an old checkerboard to give it an authentic atmosphere of earlier times. Also in the immediate vicinity of the store is the Deepwells Farm site, which preserves the legacy of farming in the St. James area. It also features a number of outdoor festivals and themed events, and this schedule is available at its website, which is www. deepwells.org.

The St. James General Store stocks a variety of nostalgia-themed goods, including candies, jellies and jams, toys, Christmas ornaments and examples of local crafts. The upstairs room, which was used for parties and dances back in the 1800s, now offers a wide selection of books about local history,

crafts and cooking. The store is located on Moriches Road, just north of Route 25A, and is open every day from 10:00 a.m. to 5:00 p.m. There is something there to please just about everyone, so stop by for a bag of old-time candy, some strawberry-rhubarb jam and maybe even a sock monkey. The visit is sure to delight children of all ages.

Chapter 8

TOWN OF BROOKHAVEN

WILLIAM FLOYD ESTATE

When someone mentions a white manor house, hundreds of acres of farmed land and the ownership of slaves, what should immediately come to mind is a large southern plantation. While this is most often the case, to many people's surprise, the same description once applied to a large estate on Long Island.

A man named William Floyd was born in Brookhaven, Long Island, in 1734 to Welsh parents and took over the family farm when his father passed away. His father had purchased the property in 1724, when the area was still a British Crown colony referred to as the Province of New York. They were a prominent family known for growing a number of labor-intensive agricultural crops, as well as livestock and fowl.

As a young man, in addition to running the family plantation, William became active in politics. He was a member of the Suffolk County Militia in the early years of the Revolutionary War and rose to the rank of major general. At various times, he served as a member of the Continental Congress, New York State Senate and representative to the First United States Congress. As a member of the Continental Congress, he was also a signer of the U.S. Declaration of Independence.

Over the years, the family farm grew to an enormous plantation of 613 acres, and as many as fourteen people working on it were slaves of African descent. Floyd also employed "free men" of color, and to his credit, he

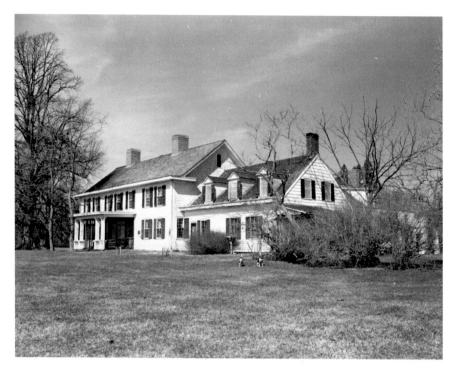

General William Floyd House, Mastic Beach, Suffolk County, New York. *Courtesy of the Library of Congress.*

slowly increased the work opportunities for local residents and reduced the plantation's dependence on slave labor. In addition to workers of African descent, the plantation also employed Native Americans from the local Unkechaug tribe, and many of these intermarried with the African American workforce

Eight generations of the Floyd family made their home on the Mastic Beach estate, and the property is presently owned and operated by the National Park Service. It is in an unlikely location surrounded by a residential community, and the entrance to the property is difficult to find. You can use a local map to get to the area of Church Road in Mastic, and then follow the fence around the property to the entrance, which is clearly marked, or simply use a GPS device if your vehicle is equipped with one. The estate is part of the Fire Island National Seashore, and the season during which it is open to visitors runs from Memorial Day through mid-November. The twenty-five-room house is fully furnished, and there are

Marker at the entrance to the William Floyd Estate. *Photo by author.*

guided tours and some special events on the grounds scheduled throughout the season. Additional information is available at the Park Service website, which is www.nps.gov.

WILLIAM SIDNEY MOUNT HOUSE

There are many historic homes on Long Island where some world-famous writer or artist chose to live a part of his or her life. Some moved to Long Island during extremely productive periods in their careers, while others lived out their later years here, enjoying what beauty and serenity the area had to offer. A rare exception to this is the painter William Sidney Mount, who was born and also died in Setauket during the nineteenth century.

William was born on November 26, 1807, and when he was only seven years old, his father passed away at the age of thirty-five. Facing the burden of raising her children alone, his mother moved the family into her parents' house in nearby Stony Brook. Young William was an extremely gifted child and started painting because his brother Henry, who owned a sign-painting

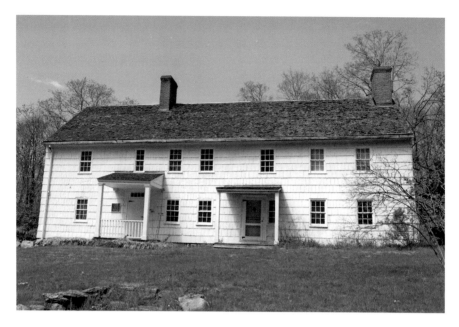

William Sidney Mount House, partially restored. *Photo by author.*

shop, encouraged him to become an artist. He was also a gifted musician, composer and inventor and developed a special violin with a hollow back to make it louder when played during barn dances.

For his formal training, William studied at the National Academy of Design in New York City and was made a full academician in 1832. His best-known paintings depicted scenes from everyday life and that of African Americans in particular. His work highlighted their talents in music and dance, and he is remembered as the first American painter to assign them the dignity that no other painters chose to represent.

William Sidney Mount died on November 19, 1868, and the home where he spent most of his life still stands in Stony Brook, at the intersection of Route 25A and Stony Brook Road. It is a yellow wood-framed house that has not been fully restored and features his studio in the third-floor attic and the skylights that provided him with enough light to pursue his work. His paintings are on display at the nearby Stony Brook museums, and he is buried in the Presbyterian cemetery in the village. The William Sidney Mount House is listed in the National Register of Historic Places and has been designated a National Historic Landmark.

HISTORIC PORT JEFFERSON

One area that is particularly rich in local history is the village of Port Jefferson, located on Long Island's North Shore. It occupies a parcel of land that was known as "Suwassett," which means "land of small pines," to the Native American people who first settled the Stony Brook and Setauket areas. In spite of this name, it was the abundance of oak and cedar trees in the surrounding woods that in later years would support the town's large shipbuilding industry.

The local Indians did not understand that selling their land to the newly arrived European settlers meant that they could no longer farm or hunt on it, and by 1655, most of the land was owned by twenty-two settler families. These early residents referred to the area by the unflattering name of Drowned Meadow, because what was to become the business district was a marshland that flooded with every high tide. It carried that name until 1836, at which time the people voted to change the name to Port Jefferson. Historians differ on their reason for choosing this name, with some favoring the theory that the name was chosen because of a favorable editorial about the town in the *Jeffersonian* newspaper and others attributing it to a prominent citizen named Elisha Bayles, who held Thomas Jefferson in high esteem.

As the town grew, it became a center of shipbuilding on the East Coast due to the large amount of hardwood available in the local forests, its well-protected natural harbor and the availability of skilled workmen who had flocked to the area. The names of early shipbuilding families like Hawkins, Mather and Bayles still figure prominently in the names of streets and local businesses in present-day Port Jefferson. In the later part of the nineteenth century, nearly 40 percent of the sailing ships built on Long Island were built in Port Jefferson, but these "golden years," as they are referred to by historians, were soon to end with the introduction of steam-powered vessels.

The area's shipbuilding industry tried to adapt to the switch over to steam power but never attained the dominance that it had enjoyed during the era of the great sailing ships. The extension of the Long Island Railroad into Port Jefferson in 1875 coupled with the scenic nature of the town and its harbor made it a popular destination for vacationers from New York City and other parts of Long Island. During this same period, the creation of the Bridgeport–Port Jefferson Ferry Company brought additional tourist traffic

Restored Port Jefferson Chandlery building. *Photo by author.*

from Connecticut, and the hotel and leisure industry in the town experienced a boom. There was a local baseball team, attractive beaches, pavilions that featured music and dancing and recreational camps that sprang up through the surrounding area. Though summer was inevitably the busiest season, the winter brought opportunities for skating and ice boating on frozen sections of the harbor, and the tourist industry thrived on a year-round basis.

In 1875, while his circus was touring Long Island, noted impresario P.T. Barnum visited the village and began to purchase property and invest in local businesses, particularly the newly formed ferry company. Most of his property was situated in an area west of Main Street known as Brick Hill, and he even had roads constructed to make it accessible from Broadway and Main Street. His plan was to build a site to house the circus during the winter months, but this was later abandoned in favor of a location that he chose in Bridgeport, Connecticut. Barnum Avenue in downtown Port Jefferson still bears his name.

The early days of the automobile figured in the history of Port Jefferson as well. In 1907, the Long Island Automobile Club staged a two-day endurance run from Brooklyn to Riverhead and back, with lunch stops both ways in Port

Jefferson. During this same period, the Port Jefferson Automobile Club came into being and staged hill climb races in the village in 1910 and 1911. Second place in the 1910 race was taken by an unusual car called the O.N.L.Y., built right in Port Jefferson at what later became the Wilson Lace Mill, just south of the Long Island Railroad tracks. The company only managed to build four automobiles, but the factory was later taken over in 1914 by the Finley-Robertson-Porter Company, which enjoyed more commercial success. FRP automobiles, as they were called, were a luxury line of automobiles that carried price tags as high as $7,000 in 1914. They competed successfully in area races but failed to qualify for the Indianapolis 500 in their one attempt in 1916. In 1925, the local hill climb race was resurrected and an FRP race car won the event, beating out the 1924 winner of the famous Pikes Peak Hill Climb. On this triumphant note, the automobile manufacturing and racing history of Port Jefferson came to an end.

Port Jefferson's shipbuilding heritage continued with America's entry into World War I. Many of the underutilized facilities that remained were reactivated to meet the country's needs in the war effort. In addition to all of the construction business that this brought, the U.S. North Atlantic Fleet of twenty vessels was deployed offshore. This provided additional business for the town as the fleet sought to supply their ships, and sailors came to town looking for places to spend their money during shore leave. With the end of the war, the town returned to being just a quaint little tourist destination and never developed as an industrial center again.

Today, any visit to the village of Port Jefferson is an enjoyable experience, and people continue to come from other parts of Long Island and across Long Island Sound from Connecticut to enjoy the town's shopping and dining opportunities. The colorful history of the area provides another dimension to any day's outing, and there are numerous remnants of its past to entice anyone with an interest in history to want to learn more. The old 1917 shipyard building has been rebuilt and now serves as a visitor's center and is a good place to begin a historic tour. There are maps of the village available there, but the best way to experience the history of Old Port Jefferson is to plan ahead and visit the Port Jefferson Historical Society's website, www.portjeffhistorical.org. It has three different walking tours of the town that can be downloaded and are a valuable guide to all of the historic buildings. Each location is numbered and highlighted on a small village map,

The 1917 Shipyard Building and Visitors Information Center. *Photo by author.*

and a brief history of the building is provided as well. There are more than fifty historic buildings covered by the three tours, but the author's personal preference is Tour Number Three, which lists twenty-eight buildings that seem to give the most variety and history of the town. So whether your interests are grabbing an ice cream cone at one of the side-street shops, enjoying a cocktail on Danford's dock or just imagining the sounds of the old shipyards or racing cars roaring up the hill, everyone who visits the historic village of Port Jefferson will come away with something.

NIKOLA TESLA LABORATORY

While Shoreham, Long Island, may have a rather infamous reputation, thanks to the failed attempt to build a nuclear power facility there in the 1980s, it was the home of some very innovative technology in the early 1900s. At that time, the town was chosen by inventor Nikola Tesla to be the site for his most ambitious projects. He named his two-hundred-acre facility Wardenclyffe and envisioned it becoming one of the first industrial parks in the nation.

Tesla came to the United States from Yugoslavia in 1884 with very little money but a head full of ideas and dreams. He was twenty-eight years old and had spent much of his life on futuristic designs that generally involved electricity and various types of motors. With an introduction from a mutual acquaintance in Paris, Tesla secured a position working for Thomas Alva Edison, who was in the early stages of bringing electric lighting to New York City. The two inventors differed on the future of electricity in the early 1900s world, with Tesla advocating alternating current as opposed to Edison, who was an advocate of direct current. When Edison reneged on several agreements to pay Tesla for work that he had done, the young immigrant walked out and started his own company. In spite of some setbacks during the Great Depression, Tesla's genius was recognized, and his inventions brought him the fame and fortune that he had always sought.

One of the scientific challenges at the dawn of the twentieth century was to perfect a device that would provide long-range radio transmission, with names such as Marconi and Edison being generally favored to accomplish it first. Tesla's dreams went beyond mere radio transmission, and he believed that it was possible to beam visual images in the same way that radio waves were transmitted and even beam electricity through the air to provide a power source to any remote corner of the globe. To achieve all of this, he designed a 187-foot-tall wooden tower with a 55-ton donut-shaped copper electrode on top and erected it at the Wardenclyffe site.

While Tesla directed most of his efforts toward his dreams of the future, his financial partners took a more practical approach to the Long Island factory and began production of electrical coils for medical instruments and a new type of torpedo for

Nikola Tesla. *Courtesy of the Library of Congress.*

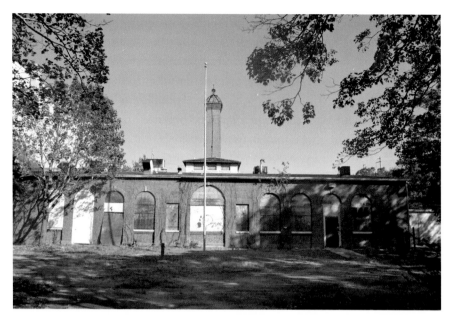

Nikola Tesla's laboratory building in 2011. *Photo by author.*

the U.S. Navy. By 1903, the power and radio transmission tower was in its testing phase, and area residents frequently marveled at the flashes of man-made lightning that lit up the night sky. Residents in Connecticut, who had marveled at the construction of the tower that they could see across Long Island Sound, now saw what looked like regular fireworks displays, as Tesla continued his experiments and ran his company deeper and deeper into debt.

In the end, Marconi beat Tesla and everyone else in the race to achieve long-distance radio transmission, and Tesla's financial troubles became even greater. Sensing his financial ruin, his regular friends and backers started to avoid him, even though some of them, like George Westinghouse, had made fortunes based on Tesla's inventions. He continued to insist that the United States should (and did) adopt a system of alternating current for its electrical needs. Creditors began obtaining judgments against Tesla and his company, and in the end, he was forced to sign over the deed to Wardenclyffe to creditors, among whom were the owners of the Waldorf-Astoria hotel company. Sadly, on July 4, 1917, the tower was destroyed in an explosion set by a salvage company, and the net return to creditors after the salvage company's costs was only $1,750.

More recent times saw the industrial site taken over by Peerless Photo Products, Inc., which was later bought by Agfa Corporation. During that period, it was a manufacturing plant for photographic film products, which unfortunately involved the dumping of enormous quantities of hazardous chemicals into the surrounding soil. The entire property has since been designated a federal Superfund site, though there appear to be no present efforts to effect a cleanup and reclaim the land. The original laboratory from the Tesla era still stands and can be seen from the road, but access to the site is prohibited in view of the toxic nature of the chemical damage. It can be reached by traveling east on Route 25A to Shoreham and making a left turn off Route 25A at the corner after Randall Road. The small side street adjacent to the property is actually named Tesla Street. Ironically, Tesla's dreams that included the transmission of clean energy are now buried under tons of soil contaminated by chemical dumping.

RCA Radio Transmitting Station

In a strange coincidence, the very organization that contributed to the downfall of another scientific project covered in this book (see previous section on Nikola Tesla) also chose Long Island as the site for a major project. Following the end of World War I, a group of leading corporations, including the American Marconi Wireless Telegraph Company, formed the Radio Corporation of America to develop a long-range wireless radio transmission system. It obtained a property covering 6,400 acres (almost ten square miles) in Rocky Point and began construction in July 1920.

On November 5, 1921, President Warren G. Harding officially inaugurated "Radio Central," as it was known, by pressing a button set up in the White House in Washington, D.C. Rocky Point, New York, now became the site of the largest radio transmitting station in the world. The completed facility consisted of a main building constructed in a pleasing Spanish architectural style, and six steel towers that were each 410 feet high. In addition to providing radio transmission technology, the RCA complex also pioneered other inventions related to communications, including early experimental work in television.

With the advent of more modern technology, particularly global satellite communications, the Rocky Point operation slowly became obsolete

The Marconi Wireless Building on Rocky Point Road. *Photo by author.*

and was slated to be dismantled. The last of the original six towers was taken down on December 13, 1977, and the facility was officially closed in 1978. Following the final closure, Radio Corporation of America transferred the land to New York State for a symbolic payment of one silver dollar, and the property remains under state control as the largest section of Pine Barrens on Long Island. Sadly, by all accounts, none of the original buildings remains standing, but the property does house an intricate network of biking and hiking trails that allows exploration of the area and turkey, deer and small game hunting during the appropriate

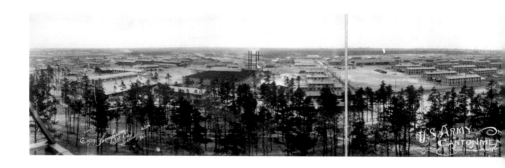

seasons. Permits to use the trails are obtainable from the New York State Department of Parks and Recreation, located on the campus of the State University at Stony Brook.

Access to the entire property is generally along Rocky Point Road or Whiskey Road to the south, and one small remnant of that era does still reside just north of the parking area for the trailhead. Just south of Route 25A on Rocky Point Road is a small white shack on the campus of the Frank J. Carasiti Elementary School. It is officially known as the Marconi Wireless Building and was originally located in Babylon. The noted inventor Guglielmo Marconi used this small building to train wireless operators and beam messages to ships at sea. It became operational in 1902 and is preserved today as a monument to this pioneering age of radio.

CAMP UPTON

The present site of the Brookhaven National Laboratory was once a U.S. Army training facility that helped the United States prepare for two world wars. It was built in 1917 and named after Major General Emery Upton, a Civil War general who wrote a number of books on U.S. military policies. The camp was designed to house and train as many as forty thousand troops in the military skills of tank, trench and gas warfare. Among the recruits who passed through its gates on the way to the war in Europe were the composer Irving Berlin and Alvin York, the most decorated army soldier of World War I. Alvin York was later immortalized in the Hollywood movie *Sergeant York*, with Gary Cooper playing the title role.

Camp Upton barracks during World War I. *Courtesy of Brookhaven National Laboratory.*

At the end of World War I, the camp filled the opposite role of demobilizing and deactivating army units returning from the war. In 1921, the federal government sold most of the buildings and equipment, and many were transported to Cherry Grove on Fire Island to form the first large-scale settlement there. The government retained ownership of the land and designated it the Upton National Forest.

Just prior to the outset of World War II, in anticipation of American involvement in the war in Europe, the government reopened Camp Upton as a training facility and later used it as a convalescent and rehabilitation hospital. Its days as an army training and medical facility ended in 1946, at which time ownership of the property was transferred to Brookhaven National Laboratory. The lab continues to conduct cutting-edge research in a wide range of scientific fields but honors the past history of the property and the valuable role that it played in both world wars. The only remaining Camp Upton structure of any size has been completely refurbished and is now known as the Brookhaven Center.

Brookhaven National Laboratory is located on the William Floyd Parkway at Exit 68 of the Long Island Expressway and is open to the public during its Summer Sunday program. Take a drive out to the grounds to find the Brookhaven Center and listen closely in the wind. You may hear the sounds of ancient bugles still blowing.

Chapter 9
TOWN OF RIVERHEAD

HALLOCKVILLE MUSEUM AND FARM

If you are ever looking for a single location that will provide multiple examples of pre-1900s life on the North Fork of Long Island, this is the place. The original homestead was built in 1765 for a man named Ezra Hallock, and he lived in it until 1801. Hallock then sold it to his brother, who gave it to his own son, Zachariah Hallock. Descendants of Zachariah continued to occupy the house until 1979, when his great-granddaughter moved into a nursing home at the age of ninety-five.

During the period from 1880 to 1910, this part of Long Island was an important farming community that supplied markets in New York City and New England with fresh produce, shipped by rail or across Long Island Sound by boat. The original Hallock farm occupied sixty acres, while the present property used to preserve the historic buildings covers twenty-eight acres. There are nineteen historic houses, barns and other buildings restored at the site and available for public viewing.

In colonial times, it was the Puritan tradition to transfer portions of the family farm to male heirs when they reached marrying age. By the 1800s, so many of the homes situated along what is now Sound Avenue belonged to members of the original Hallock family that locals began referring to the area as "Hallockville," but it is officially the hamlet of Northville.

By the early 1900s, a large number of Eastern European immigrants began settling in the general area of the Hallock family holdings, and some

of the properties passed out of the hands of the Hallocks to families with names like Trubisz, Sydlowski and Cichanowicz. As further development continued in the area, these farm properties continued to be subdivided into smaller home plots, but the Hallockville Museum has been able to preserve much of the character of the earlier era by moving a number of these early 1900s homes onto the museum property.

The museum and farm presently host school programs as well as guided and self-guided tours of the property and buildings. There is an adult admission charge of seven dollars or four dollars for seniors and children. To reach the museum, you head east on Route 25A through Shoreham to the point where Sound Avenue veers off to the left. Take Sound Avenue east about twelve miles, and the Hallockville exhibit will be on the left. The buildings are not always open for inside tours, so check their website at www. hallockville.com or call ahead to schedule a tour. If you time your visit right, you might run into Captain Jack Combs in the decoy shop, demonstrating his family's traditional woodcarving and regaling you with tales of the baymen and the history of Long Island's North Fork.

Hudson-Sydlowski House, circa 1840. *Photo by author.*

"THE BIG DUCK"

For more than eighty years, no trip to the eastern part of Long Island would be complete without a visit to "The Big Duck." Built in 1931, the duck measures thirty feet from beak to tail, fifteen feet in width by twenty feet high and sits on Route 24 in the town of Flanders.

The idea for the duck came from Riverhead duck farmer Martin Maurer and his wife, Julie. They decided to increase sales at their store by having a shop in the shape of a duck built out of cement. It was an idea they had gotten during a trip to California, when they stopped at a roadside coffee shop that was shaped like a giant coffeepot. The Maurers hoped that by building a tourist attraction they would increase sales of the Peking ducks that they were growing locally at their Big Duck Ranch. They hired a local carpenter and two stage-show set designers and used a live duck tied to their porch as a model.

Construction started with a large wooden frame over which wire mesh was attached, and then the entire structure was covered with cement. It

Unmistakably, "The Big Duck." *Photo by author.*

was painted bright white with a yellow beak, and two Model-T automobile taillights were used as eyes, so that they would glow red at night. The finished shop stood on West Main Street in Riverhead until 1936, when it was moved to its present location in Flanders. In 1987, when its existence was threatened by development of the area, a community effort to preserve the duck succeeded, and its owners at that time generously donated it to Suffolk County.

"The Big Duck" has been listed on the National Register of Historic Places and is maintained by the Suffolk County Department of Parks & Recreation. While the store no longer sells poultry, it is still in use as a tourism office that also sells souvenirs, books on Long Island history and some locally produced food items. It is easily reached by driving through Riverhead and following the signs to Route 24 South. Heading south it is located on the left side of the road and can't be missed. After all, it is a twenty-foot-tall duck!

Chapter 10
Town of Southold

Fort Corchaug

If your interest in history is a little more adventurous than walking through a museum or listening to a guide in an old house explaining what daily life was like for its occupants, you may want to visit the archaeological site in Cutchogue known as Fort Corchaug. Unfortunately, there really is not much to see there. It is a fifty-one-acre parcel of land with hiking trails on Downs Creek, but it offers the opportunity to get closer to Native American history than any other place on Long Island.

Long before European settlers began to arrive on Long Island, this part of the North Fork was home to a group of Indians known as the Corchaugs. They occupied one of the many Native American settlements on the east end of the island that were known collectively as Metoac. It is believed that this term is a derivative of the local word "metau-hok," which described the shell of the rough periwinkle that was used as currency in the Indian economy.

There is little recorded history about the Corchaug tribe, but when English settlers arrived on the North Fork, they found an old wooden fort in the area that was to become Cutchogue. Using what evidence could still be found in the area, historians have suggested that the fort would have been built out of tall trees that rose vertically out of a trench and measured 210 feet by 160 feet, surrounding an area of approximately three-quarters of an acre. It would have been at the center of an Indian village that is believed to have cultivated corn, beans and tobacco.

Road marker at the entrance to Fort Corchaug and the Downs Farm Preserve. *Photo by author.*

Noted archaeologist Ralph Solecki, of Texas A&M University, who grew up in the area believes that the fort was built with the help of Dutch and English traders who desired to help the Corchaugs protect themselves from other Indian tribes such as the Pequots of New England. The Europeans would have traded with the Corchaugs for the shells used as wampum and then used the wampum in their trading for furs with tribes in upstate New York.

The sign marking the property as an archaeological site also mentions the Downs Farm, which stood on this property in the 1800s. There are several remnants of the old farm on the property, and the Peconic Land Trust is working to preserve more of the heritage of the Downs family. The Fort Corchaug/Downs Farm Preserve is regarded as one of the best-preserved sites in the New England region for the study of seventeenth-century Indian life. When hiking the trails, one will experience the natural beauty of the area, which includes a section of wetlands and a salt marsh. The entrance to the property is on the south side of Route 25 in Cutchogue, near Elijah's Lane and opposite the entrance to Pellegrini Vineyards. It was named a National Historic Landmark in 1999 and remains one of Long Island's little-known historic treasures.

GREENPORT RAILROAD YARD

The village of Greenport is rich in nautical tradition, but it also played a vital role in the development of rail service on Long Island. Some railroad historians even believe that access to Greenport was the sole reason that the Long Island Railroad was created.

Picture, if you will, the Long Island of the early 1800s. It would have consisted mostly of farming communities and a whaling industry but with no real system of roads to allow easy movement over the length of the island. What it did have at its east end was an excellent harbor at Greenport that would allow access to Boston and all of New England by water. The port was already busy with whalers and fishing boats bringing in their catches, but the great distance from New York City limited the amount of commerce that could be conducted. Manufacturers in New York City were also feeling limited in their ability to sell their goods in New England, because there was no real rail service to connect them to those markets.

Transportation planners at the time looked to establish a direct rail link between New York and Boston but felt that the hilly terrain of Connecticut and Rhode Island would make that a costly venture. The alternative was to take advantage of the flat terrain of Long Island and combine the capabilities of rail and water transport to create an efficient transportation system. The Long Island Railroad was chartered in 1834, and by 1844, the ninety-four-mile track link between New York and Greenport was completed. The plan at that time was to transport goods from New York to Greenport, load them on ferries to Stonington, Connecticut, and then offload them to complete their journey by rail up to Boston. Probably due to the complexity of this system, it was not readily accepted by the industry, and by 1850, the rail line through Connecticut and Rhode Island that was first rejected had been completed. The amount of business that had been anticipated as going through Greenport never materialized.

What did happen, however, was that all along the Brooklyn to Greenport line, communities and industrial zones developed. Farmers on Long Island's east end were able to bring their produce to Greenport and ship it through New York to other markets. Tourists from New England were able to sail to Greenport, do a brief stopover and then go on to New York City. The industry developing along the railroad right-of-way sparked the creation of

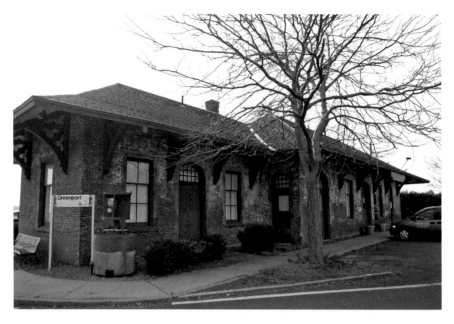

Original Greenport passenger station, circa 1894, now the East End Seaport Maritime Museum. *Photo by author.*

new residential communities, and Long Island began to prosper as it had never done before.

The remnants of this era of innovation still exist in Greenport in the form of the old passenger station and freight terminal, both of which date back to 1894. The passenger station now houses the East End Seaport Maritime Museum, while the freight terminal is home to a satellite location of Riverhead's Railroad Museum of Long Island. In addition to this, the yard area also contains one of the three remaining railroad turntables on Long Island that are still operable. These were used to turn engines around for the return trip to New York and saved the necessity of building a large loop of track to point the engine back west.

Both buildings and the turntable are in the area that is now used as the waiting line for the Sag Harbor ferry. The museums house a variety of interesting exhibits and are a worthwhile stop for anyone visiting Greenport. Outside of the old freight depot are a vintage wooden caboose and a diesel-powered snowplow with the unlikely name of "Jaws III." Children will love to have their picture taken next to its massive jaws, while learning about an exciting period in Long Island history at the same time.

HORTON POINT LIGHTHOUSE

Because of its long seafaring tradition, lighthouses figure prominently in the history of Long Island. One of the more accessible of these is the Horton Point Light overlooking Long Island Sound in the town of Southold.

In 1756, twenty-five-year-old George Washington left Virginia on horseback and stopped off on Long Island with the intention of boarding a Boston-bound ship in Greenport. During his visit, he became acquainted with Ezra L'Hommedieu, who was later to become a Revolutionary War hero, and the two discussed the need for at least two lighthouses on Long Island. Thirty-four years later, when Washington became president, he commissioned the construction of two lighthouses to be built at Montauk Point and Southold. Work was begun soon after on the Montauk Point Light, but additional funds were not available, and so the North Shore light construction was put on hold. It was not until 1854, nearly seventy years later, that the funds were finally allocated and the necessary land was purchased. The price of the land on which the lighthouse still sits was $550, and the construction was finally completed in 1857.

View of the lighthouse from the bluff overlooking Long Island Sound. *Photo by author.*

The original facility consisted of a fifty-five-foot-tall tower and a separate two-story lighthouse keeper's residence. The buildings were later joined by a connecting annex and sported decorative rainspouts shaped like gargoyle heads and provided light from a single whale-oil lamp. In 1871, the station underwent major renovations, including the addition of extra rooms for the assistant keeper and a cast-iron deck and railing on top of the tower. Though modified on several occasions, the original light tower continued to operate until 1933, at which time it was replaced by an automated light on a forty-foot steel tower erected on the property.

Because of its vantage point overlooking Long Island Sound, the lighthouse was used by the Civilian Defense Corps as a lookout point during World War II. It then sat abandoned and neglected for years after the war. The Southold Park District had purchased it from the U.S. Department of Commerce in 1934, but restoration was only begun in 1976. A nautical museum was added in 1977, and the property continues to be maintained jointly by the Southold Parks District and the Southold Historical Society. In 1990, the steel tower was removed and the original light tower was placed back in service. It is listed in the National Register of Historic Places and is open seasonally to visitors.

The lighthouse property sits on a sixty-foot-high bluff overlooking Long Island Sound, and a steep wooden stairway at the edge of the property allows access to a small beach below. The beach is extremely narrow and appears, for the most part, to be impassable at high tide. A path designated as the Lighthouse Park Nature Trail begins at the west end of the property and allows visitors to experience close encounters with deer and other local wildlife. There are street markers in the town of Southold clearly showing the way, and the park can be reached using Youngs Avenue in town to get to the north end of Lighthouse Road. Bring a picnic lunch and enjoy the fresh air and views of Long Island Sound, while learning more about an important part of Long Island's nautical history.

FIRST U.S. NAVY SUBMARINE BASE

In 1873, an Irish schoolteacher by the name of John P. Holland immigrated to America and brought with him a vision that would revolutionize naval warfare

forever. For years he had tinkered with designs for a submarine boat, and while working as a teacher during the day, he continued to revise his designs and attempted to raise the capital necessary to build a prototype submarine.

He was successful in obtaining the necessary backing and formed the Holland Torpedo Boat Company, which built a number of moderately successful submarines. By 1898, the new company had completed the *Holland VI*, its most successful prototype to date, and entered it into a competition that the U.S. Navy was sponsoring in its search for a workable submarine design. Even though all of the work thus far had been at a shipyard in New Jersey, it was felt that the waters of Long Island would provide a better testing ground for the new submarine. The hamlet of New Suffolk was chosen as the location for further testing of the boat, and the company leased the Goldsmith & Tuthill Shipyard in New Suffolk in 1898. The *Holland VI* was towed there in June 1899 for sea trials and final design changes.

The Holland design won the navy competition, and on April 11, 1900, the U.S. Navy purchased the *Holland VI* and gave the company a contract to build six additional submarines. With the commissioning of the *Holland VI* on October 12, 1900, New Suffolk officially became the U.S. Navy's first submarine base designated Holland Torpedo Boat Station. Six additional submarines built at various locations were completed and tested in the waters off New Suffolk during the next five years, before the operation was moved to Groton, Connecticut, as the Electric Boat Division of General Dynamics Corporation. While General Dynamics continues to build submarines to this date, the submarine museum in Groton gives appropriate credit to New Suffolk, where it all really began.

A trip to the site begins with a drive out to the village of Cutchogue on Route 25 and then a right turn on to New Suffolk Road. Route 25 is clearly marked with a sign pointing toward New Suffolk, and a left turn off New Suffolk Road on to New Suffolk Avenue will bring you right to a historical marker at the end of a parking area. The total distance from Route 25 is only about two miles.

The historical marker celebrates the site as the location of the first U.S. Navy submarine base. There is a rapidly deteriorating jetty pointing out into Peconic Bay and the remnants of a seawall that connected to the jetty to provide a more protected stretch of water in which to moor the submarines.

Goldsmith & Tuthill Shipyard in 1899 with five of Holland's submarines. *Courtesy of the Submarine Library.*

If you are at the marker sign and looking out into the bay, the old Holland Torpedo Boat Factory buildings would have been to your right. The sandy beach that you see did not exist back in 1901, and water came right up to a bulkhead that would have been at the top of the present beach. Some of the old timber for the bulkhead is still visible, but it is mostly buried in the sand. Out on the jetty there are numerous old rusty steel rods and parts of machinery that all were part of the submarine factory. Some of the old buildings were still standing in the 1980s and were being used by a windsurfing school and other nautical-type businesses. Hurricane Gloria in 1985 did not actually destroy the buildings but did weaken them to the point where they had to be torn down as a safety measure. There is some local interest in creating a museum to commemorate the history of the New Suffolk waterfront, and this important chapter in Long Island's past may yet see the recognition that it deserves.

Custer Institute

When most people think about astronomy and a place to view the night sky on Long Island, it is the Vanderbilt Planetarium in Centerport that comes to mind. A planetarium is actually nothing more than a room with a domed ceiling and a projector that produces simulations of stars and planets by using beams of light. While there are telescopes and groups that meet at the Vanderbilt facility to look at the night sky, these are not usually open to the general public. Less well known is the Custer Institute in Southold, which was established in 1927 and is Long Island's oldest public observatory.

Charles Wesley Elmer was a court reporter with a lifelong interest in science, and astronomy in particular. He owned a summer home in the area of Cedar Beach on Long Island and would regularly invite his amateur astronomer friends out to his home on weekends. Long Island's clear night skies, free of light pollution, offered the group conditions that were far superior to anything that they could experience in New York City. Among this group was Henry Perkin, with whom Elmer would later establish the Perkin-Elmer Optical Company, which produced precision lenses and related optical products.

In 1927, the members of the group decided to formalize their organization and named themselves the Custer Institute, to honor Elmer's wife, May. Her maiden name was Custer, and she was the grand-niece of General George Armstrong Custer. Charles felt that this was a way to repay her for the many years that she had been such a gracious hostess at all of the group's informal gatherings at their home. In 1938, the group purchased a parcel of land in Southold, and the institute has continued to operate out of that location for more than seventy years.

In 1945, a three-story tower and dome were built to house the institute's largest telescope. There are other telescopes situated throughout the property that allow visitors to use equipment more powerful than what is generally available to the backyard astronomer. The museum portion of the main building houses a collection of vintage telescopes and assorted scientific memorabilia. There is also a library that includes science and astronomy books dating back to the 1800s, decades of astronomy periodicals and a thirty-five-millimeter astronomical slide collection.

The Custer Institute, with the main observatory dome. *Photo by author.*

The Custer Institute is chartered as an educational nonprofit organization, and its stated mission is to increase public awareness in the field of astronomy. There are events scheduled for most Saturday evenings that include viewing the sky through telescopes, as well as the occasional lecture, music performance and special holiday party. The suggested donation charge is five dollars for most events, and the institute is located on Main Bayview Road, just south of Route 25 in Southold. The full calendar and more information are available at its website, which is www.custerobservatory.org.

Chapter 11
TOWN OF EAST HAMPTON

BULOVA WATCHCASE FACTORY

History is filled with twists and turns that sometimes produce the most unexpected outcomes. One such series of events resulted in a huge factory being built in Sag Harbor, at a time when Long Island was not nearly as developed as it is today.

Joseph Fahys was born in Belfort, France, in 1832 and immigrated to the United States with his mother in 1848. He worked as an apprentice at a watchcase manufacturer in New Jersey and in 1857 bought that business from its former owner. In an effort to make the business more efficient, he first moved that factory to New York City but then moved it back to a different New Jersey location. By 1867, his business had expanded, and in partnership with another firm, he opened a second factory in Brooklyn. His next move would be to relocate the New Jersey plant to the unlikely location of Sag Harbor.

The town of Sag Harbor has a long history involving the whaling industry, but by the late 1800s, with the use of fossil fuels increasing, the demand for whale oil and related products was beginning to decline. Many Sag Harbor families had amassed small fortunes from the whaling industry, and so there was no shortage of investment capital to fund a completely new venture. The factory was built in 1881, but there are some discrepancies in the historical record as to who actually commissioned the building. Fahys had married a

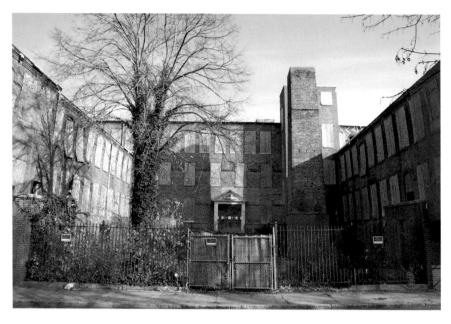

The abandoned Bulova Watchcase Factory. *Photo by author.*

woman from Sag Harbor in 1856 and was familiar with the area, so it was no surprise that he chose to move one of his plants this far out on Long Island. He and his son-in-law purchased several parcels of land near Peconic Bay and built their summer homes in Sag Harbor as well.

The new factory created an immediate demand for labor, and its manufacturing floors were filled with retired seamen and immigrants. The company maintained an excellent reputation for clean workspaces and employee benefits and produced gold and silver watchcases that are highly collectible today. In 1890, it was reported that the plant output required that $6,000 worth of gold be melted down each day. Things were going well, but since it produced what would be called a luxury item, it was only natural that the Great Depression would take its toll on Joseph Fahys & Company. In 1931, faced with some financial stress and increased competition, Fahys sold the plant to Mr. Arde Bulova. The new owner renovated the building and changed the company's name to Bulova Watchcase and continued to produce watchcases until 1975. During World War II, much of the production at the factory shifted over to timing devices for military munitions.

As markets changed and overseas competition increased, Bulova eventually closed the plant in 1975, and it has remained unused and in decay ever since. As of 2011, there are plans for development of the building into a residential housing complex, but until that is done it will sit as an empty shell on Church Street in the heart of Sag Harbor. The halls and factory floor are empty, and it is pretty much a certainty that every little bit of gold scrap that might have fallen to the floor years ago has been claimed by someone by now.

MONTAUK POINT LIGHTHOUSE

The bumper stickers for Montauk, Long Island, read: "Montauk—The End." While this statement is accurate if one is traveling east from New York City, in another sense, Montauk was more of a beginning. For many generations of immigrants, the light at Montauk Point marked their first glimpse of America. It symbolized the fulfillment of their dreams and the start of a new life in the United States.

In his early years, George Washington was both a surveyor and a mapmaker. During a visit to Long Island in 1756, young Washington recognized the need for lighthouses on the Long Island shoreline. When he later became president, he ordered that two lighthouses be constructed on Long Island. The first of these was the Montauk Point Light that was built in 1796 at a cost of $22,300. The site chosen was known at the time as Turtle Hill and had a long tradition of being used by the local Montauk Indian tribe for signal fires to call chiefs and warriors to council meetings. During the Revolutionary War, as British warships sought to blockade the entrance to Long Island Sound, they kept large fires burning on the hill to act as a beacon.

The construction of the lighthouse was the first public works project undertaken by the new United States government. With a foundation that went down thirteen feet and walls that were seven feet thick, the lighthouse was built like a fortress. President Washington was often quoted as saying that the lighthouse would stand for two hundred years, and his prediction has proved to be even a bit conservative. Among the many legends surrounding the area is one involving the pirate Captain Kidd, who is said

A view of the lighthouse from the parking area. *Photo by author.*

Montauk Point Lighthouse. *Courtesy of the Library of Congress.*

to have buried treasure there in 1699. The two ponds mentioned in the stories are referred to today as "Money Ponds" and are marked by a sign adjacent to the lighthouse

Up until the 1920s, the last few miles of roadway leading to the lighthouse were unpaved and somewhat treacherous. This isolation made the site popular with smugglers during the era of Prohibition, and in 1925, a father and son who manned the light were suspected of working with the smugglers and bootleggers. During World War II, the lighthouse was taken over by the U.S. Army and made a part of the Eastern Coastal Defense Shield. It has the distinction of being the first lighthouse in New York State and the fourth-oldest active lighthouse in the United States.

A trip to the Montauk Point Lighthouse could not be easier. Just head east on the South Shore of Long Island on Route 27 until you cannot go any farther! It makes for a wonderful day trip with a visit to the lighthouse and its adjacent museum, followed by a beach hike west toward Long Island Sound to look for seals sunning themselves on the rocks close to the shore. The lighthouse is open every day during the summer and on weekends for most of the remaining months of the year. It is maintained by the Montauk Historical Society, and you can call (631) 668-2544 to check on the hours that it is open to visitors.

OLD WHALER'S CHURCH

The village of Sag Harbor is as rich in history as any place on Long Island. One of the most interesting aspects of the village's history is the indomitable spirit of the people who made up the town's Presbyterian church congregation.

Historic records place the settlement of Sag Harbor as having occurred sometime between 1707 and 1730. The townspeople gathered on February 24, 1766, to discuss building a church, and the Presbyterian faith seems to have been the dominant religion at that time. While the actual date is unclear, they decided to erect the town's first church, which its own minister described as a "mere frame with outward covering." It was noted that in the event of showers during a religious service, the minister had to seek shelter under a corner of the pulpit to avoid getting soaked.

The present front view of the church without the steeple. *Photo by author.*

By 1816, the town had grown to the point where the residents decided to build a proper church, and so they tore down the "Old Barn Church." Some of the wood from the old building was used in construction of the new church, but Sag Harbor was devastated by a fire in 1817 that destroyed many of the buildings. Fortunately, the new church survived and served the community until it also was replaced in 1844. After the Presbyterian congregation vacated that building and moved to the church that now sits at 44 Union Street, the second church building burned down as well in 1924.

The residents had strong feelings about what that third church should look like, and they chose architect Minard Lefever to design something that would be truly unique. They envisioned something that would symbolize Solomon's Temple from the Old Testament of the Bible, and so the church was built in what would be described as Egyptian Revival style. The village of Sag Harbor was prospering at that time, with the whaling industry alone generating millions of dollars in business for the local economy. At one time, as many as sixty-three whaling ships called Sag Harbor their home port, and this created jobs for more than 1,800 men in the village. Because of this, no expense was spared in creating the new church, and the present site on

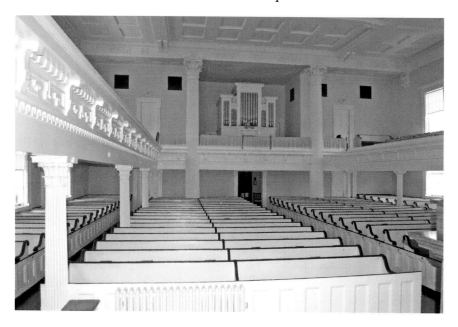

An interior view of the church showing the organ in the rear choir loft. *Photo by author.*

Union Street was purchased for $2,000 and the building was erected for an additional $17,000.

When the church was dedicated in 1844, it included a 185-foot-tall steeple that really did not fit the Egyptian theme of the rest of the building. The design of the steeple more closely reflected influences of Greek architecture, and it was visible to ships as they rounded Montauk Point on their way to the village. In 1938, a hurricane that tore through the town destroyed the steeple, and there remains a difference of opinion among local residents as to whether or not it should be rebuilt.

To a visitor approaching the building today, its resemblance to an Egyptian temple is unmistakable. The exterior is an uncluttered design of white cement, and there are carvings on the cornices that are meant to symbolize whale-cutting tools. In spite of some elements of Greek design, the overall impression is of an Egyptian temple. Many experts regard the church as the most important example of Egyptian Revival–style architecture in the United States.

Inside the church, one is again struck by the Egyptian theme as well as elements of the Greek Revival style. The large organ situated in the loft at

the rear of the church is fashioned to look like a miniature version of the entire church building. Old Whaler's Church is one of the most recognizable buildings in Sag Harbor and is listed in the U.S. National Register of Historic Places and designated a National Historic Landmark. Just adjacent to it is an old graveyard that has its own history as well. A sign there dates it back to 1767 and notes that nineteen veterans of the Revolutionary War are buried there. There is a second sign that commemorates the Revolutionary War Battle of Sag Harbor that took place in 1777. Any visit to this part of Union Street, coupled with stops at the nearby Whaling Museum and Custom House Museum, will provide visitors with a full day of touring in this lovely town and an enormous amount of information about the history of this part of Long Island.

THOMAS MORAN HOUSE

Just at the edge of the shopping area in the town of East Hampton, across from the picturesque pond and a short distance west of the Maidstone Arms Hotel, sits an old house in a total state of disrepair. It was declared a U.S. National Historic Landmark in 1965, because it was at one time the home of a famous American painter.

Thomas Moran was born in England on February 12, 1837, and began his career in Philadelphia as a teenage apprentice at a wood-engraving firm. He used his free time to perfect his painting skills and became known as an exquisite colorist. His illustrations in major magazines and gift catalogues led to some recognition of his talent, but it was his paintings of the American West that brought him his fame.

In 1871, Dr. Ferdinand Hayden, director of the United States Geological Survey, invited Moran to join an expedition into the then unknown Yellowstone region. The expedition was to be funded by American financier Jay Cooke and the new illustrated magazine *Scribner's Monthly*. During their forty days in the wilderness area, Moran documented over thirty different sites and produced a diary of the expedition's work. His sketches, along with photographs taken by William Henry Jackson, captured the imagination of the American people and inspired the U.S. Congress to establish the Yellowstone region as the nation's first national park. Moran took so much

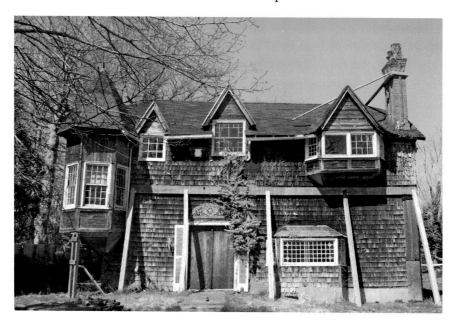

A view of the Thomas Moran house in 2012 prior to any restoration. *Photo by author.*

pride in this accomplishment that he began using "T-Y-M" as his signature, which was meant to signify Thomas "Yellowstone" Moran.

He followed up this success producing other paintings of the western states, several of which were purchased by the U.S. Congress to hang in the Capitol Building. These eventually found their way to the Smithsonian American Art Museum, where they are still on display. For the next forty years, he traveled extensively, solidifying his reputation for painting breathtaking scenes of the American West. In recent years, during the administration of President Barack Obama, Moran's painting entitled *The Three Tetons* was hung on the wall of the Oval Office in the White House. It hangs just to the right of the fireplace and frequently appears in television coverage of meetings in the Oval Office between the president and other heads of state.

Thomas Moran lived in the East Hampton house from 1884 until his death in 1926. He and his wife, Mary Nimmo Moran, also a painter, are buried across the street from the house in the South Side Cemetery by the town pond. The house remained privately owned until 2004 and was then left to the owners of Guild Hall in East Hampton. Ownership was transferred to

the Thomas Moran Trust in 2008, and the trust is attempting to raise funds to restore it and give it the respect that it deserves as a National Landmark.

BRIDGEHAMPTON RACE CIRCUIT

To the casual visitor out for a leisurely drive on the back roads between Bridgehampton and Sag Harbor, it would be a big surprise to learn that he was driving over an area that had made automotive history. From 1957 until the late 1960s, the Bridgehampton Race Circuit was regarded as one of the most challenging road racing courses in the entire world.

As early as 1915, the town of Bridgehampton was hosting automobile races that were run over the local streets, which was quite common during that period. In 1952, there was a serious accident at a race run on the local roads in Watkins Glen in upstate New York. Following this incident and in the face of public pressure, racing over state-maintained roadways came to an end. It took several years for the town of Bridgehampton to locate another site, and in 1957, the new circuit officially opened. Road racing courses differ from oval track racing in that there are a number of turns built into the circuit that increase the difficulty in negotiating the track at high speeds. The Bridgehampton Race Circuit, known as "The Bridge," was 2.85 miles in length and featured a total of thirteen turns.

Many of the drivers who are still held in high esteem in motor racing circles spent some of their early years competing at "The Bridge." Renowned drivers such as Stirling Moss, Bruce MacLaren, Dan Gurney and Briggs Cunningham all faced the challenge of Bridgehampton and came away describing it as "fearsome" and "requiring the utmost of driver skill." From the mid-1960s to the early 1970s, a series of races known as the Canadian-American Challenge Cup caught the interest of automobile racing enthusiasts all over the world. The cars in the series were generally constructed of fiberglass or very light metals and were powered by American V-8 car engines that produced as much as one thousand horsepower. The Bridgehampton races that were part of this series lured as many as fifty thousand racing fans to this small town on Long Island's east end. At the 1966 Can Am race, Dan Gurney became the first American driver to win a race in the series.

One of the more significant "firsts" at "The Bridge" came in 1967 with the entrance of a car known as the Chaparral 2E in the annual Can-Am race. The car featured a movable rear wing known as a spoiler and body streamlining on the bottom of the car that was known as ground effects. After an impressive start in which the car dominated the rest of the field, it was forced to drop out with engine trouble later in the race. In spite of this early setback, that day marked the beginning of racing technology that has continued to be a vital part of sports and Grand Prix racing cars more than forty years later. The era of the racing car "wing" had begun, and automobile racing would never be the same.

As maintenance costs grew and newer courses started to attract the most popular races, it was only a matter of time before the days of world-class racing would end for Bridgehampton. By the 1970s, it was still in use for amateur sports car and motorcycle races, but bowing to public pressure, the track was finally closed in 1999. Most of the track and infield areas now house a golf course and luxury homes, but there are a few small sections of the original racecourse that are being preserved.

If you drive north on Head of the Pond Road from Southampton, bear left at the fork on to Millstone Road and look to your right, you are looking at the old Bridgehampton Race Circuit. A group of dedicated racing enthusiasts known as the Bridgehampton Racing Heritage Group is making an effort to preserve the history of the track, and there is a wealth of information available at its website, which http://bridgehamptonraceway. com. If you are a golfer and have a chance to play the course, when you walk the fairways for the fifth, sixth, ninth and eleventh holes, you are crossing over an area where race cars once competed at speeds of close to two hundred miles per hour.

CAMP HERO

Situated right next to the Montauk Lighthouse property is Camp Hero State Park, the location of a military installation that played a part in this nation's defense as far back as World War I. Even during the Revolutionary War, the eastern tip of Long Island was regarded as vulnerable to a British invasion and of strategic importance in defending the colonies.

Camp Hero gun emplacement bunker. *Photo by author.*

During World War I, the U.S. Army stationed reconnaissance dirigibles, aircraft and troops at the site that would become Camp Hero. It was commissioned as Fort Hero in 1929 to honor Major General Andrew Hero Jr., who was the army's chief of coast artillery. By World War II, with German submarines patrolling the East Coast and landing spies and saboteurs on local beaches, Montauk was again considered vulnerable to invasion. The base at Fort Hero was upgraded by the army and renamed Camp Hero in 1942.

Around this same time, the U.S. Navy acquired land adjacent to the army base and built seaplane hangars, barracks, support buildings and a torpedo testing facility. The combined base was officially known as the U.S. Military Reservation, but to local residents it continued to be known as Camp Hero, a name that has stuck with it for more than sixty years. It was then expanded to 278 acres and housed four sixteen-inch artillery pieces in concrete bunkers and pointed out to sea. A variety of machine guns, anti-aircraft guns and other artillery pieces were added to the base, and it became self-sufficient with its own recreational facilities and power plant. To disguise its existence from surveillance by enemy aircraft and Nazi spies, the entire base was built to look

like a New England fishing village. The concrete bunkers had windows painted on them and ornamental roofs with false dormers, and the gymnasium was made to look like a church with a tall steeple. When the war ended, the base was temporarily shut down and used as a training facility by the army reserves.

With the onset of the Cold War in the 1950s, a portion of the base was turned over to the air force's 773rd Aircraft Control and Warning Squadron. Its mission was aircraft spotting and identification, which remained true to the long-standing tradition of the area being used as an early warning site for enemy activity. State-of-the-art surveillance and radar equipment was installed at the base, and in 1957, when it was realized that Soviet bombers could fly well out of the range of ground-based artillery, the eastern portion

SAGE radar unit antenna in 2012. *Photo by author.*

139

of the site was donated to New York State. The air force continued to operate a Semi-Automatic Ground Environment (SAGE) radar system on the site until 1980, when it was replaced by a new system in Riverhead that was operated by the Federal Aviation Administration.

When Camp Hero was closed, the land was donated to the National Parks Service, which later turned it over to the New York State Department of Parks. It was opened as Camp Hero State Park in 2002 and offers excellent surf fishing, hiking, cycling and picnic opportunities to visitors. Much of the history of the site is still in evidence, including the SAGE radar unit with its 128-foot-long, forty-ton antenna. The World War II bunkers that housed the sixteen-inch guns are still there, now buried under a hillside covered with natural trees and brush, but the entrance doors and concrete gun ports are still visible. Much to the credit of the Parks Department, there are signs throughout the park marking the sites of the old anti-aircraft guns, bunkers and of course the radar installation, so that a hike through the park provides a great deal of information about the area's history. It is a beautiful location to visit, and a couple of moments standing on the sand cliffs looking out over the water will give visitors a sense of what it was like to stand there as a lookout, wondering if an enemy ship or aircraft would appear on the horizon in the next few seconds.

POLLOCK-KRASNER HOUSE

Long before the east end of Long Island was as popular with celebrities as it is today, an artist who would go on to achieve worldwide acclaim chose to make his home there. The painter Paul Jackson Pollock, more commonly known as Jackson Pollock, lived in the village of Springs from 1945 until his untimely death in 1956.

Pollock was born in 1912 and began to study painting in 1929 at the Art Students' League in New York City. His early work was related to the more unconventional style of painting known at the time as Surrealism, or that influenced by a group of painters known as Regionalists. From 1938 to 1942, he worked under a program called the Federal Art Project and by the mid-1940s was painting in a completely abstract manner. His technique was described as the "drip and splash" style, because instead of working on

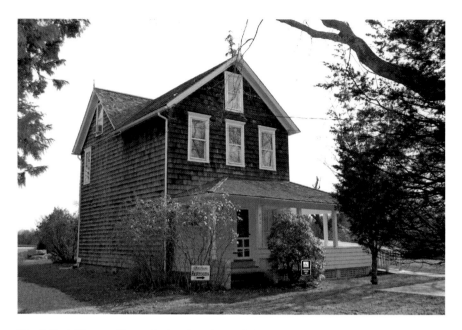

The Pollock-Krasner House during the winter of 2011–12. *Photo by author.*

a canvas mounted on an easel, he would lay a canvas on the floor and pour paint onto it. He would then manipulate the paint using sticks, trowels or knives and sometimes mix sand or broken glass into the mixture to achieve a more textured effect.

In 1944, Pollock married another artist named Lee Krasner, and in 1945 they moved into the house on Long Island that became his home for the rest of his life. Unlike the more trendy locations that we have come to expect of celebrities, the couple chose to purchase a home that had an East Hampton mailing address but was more reflective of the nearby town of Springs. They paid $5,000 for the house and its 1.36-acre lot that overlooked Accobonac Creek. Pollock at first used an upstairs bedroom as his studio but later moved into a small barn on the property and left the bedroom studio for Krasner to pursue her own work.

Not everyone in the art community held the same appreciation of Pollock's style, and he was frequently held up for abuse and sarcasm by others who did not recognize its importance. He was generally regarded as a reclusive artist and struggled with alcoholism for most of his life. In 1956,

Time magazine dubbed him "Jack the Dripper" as part of its criticism of his style of painting. Finally in the 1950s, the art community began to recognize his influence on the new styles of painting that were emerging, and as is all too typical, his work was not truly appreciated until after his death. Jackson Pollock died in an alcohol-related automobile crash on August 11, 1956. By the 1960s, he was regarded as an important figure in one of the most important movements in American painting. His work has been exhibited throughout the world, and his life was the subject of an Academy Award–winning film in 2000 starring Ed Harris.

The house is located at 830 Springs Fireplace Road and is easily reached through the town of East Hampton. Guided tours are available from May 1 through October 31 for a ten-dollar fee, but check the website www.pkhouse. com for more information about the available hours. It was declared a National Historic Landmark in 1994 and has a beautiful view of the adjacent creek that one would hope inspired Pollock in some of his work.

Chapter 12
Town of Southampton

Halsey House

Situated just south of the village of Southampton lies a landmark known as Halsey House, which is believed to be the oldest English-style house in the state of New York. It was built in 1640 by Thomas Halsey, who had sailed to the New World from England in 1630.

Halsey first settled in Lynn, Massachusetts, and was one of the earliest residents of the Massachusetts Bay Colonies. In the 1640s, he was one of the first Englishmen to relocate to Long Island, and in 1640, he built the house that presently stands on South Main Street. The records indicate that this early group of settlers, in what would become Southampton, purchased a large tract of land from the local Indians for sixteen coats and sixty bushels of corn. The Halsey homestead was known in colonial times as "Hollyhocks," which refers to a plant with large flowers that may have been prominent on the property at that time.

Because Thomas Halsey was just an ordinary farmer with no significant place in history, there are some conflicting facts about his family in the historical records. By one account, Halsey's wife, Phoebe, who bore him seven children, was scalped by Native Americans in 1649. One can only speculate that there may have been some conflict with the local Indians over the price paid for the land, and that this resulted in violence. In a conflicting record, however, Halsey's will, dated July 28, 1677, refers to a wife and specifies the exact items in his estate that he wished to leave to her. It is

The Halsey House, as seen from South Main Street. *Photo by author.*

unclear whether this is an actual contradiction or if Halsey remarried. The will also only lists four children, so it is difficult to get a complete picture the family history.

Moving beyond some of these finer details, what is important is that this homestead presents an accurate picture of the daily lives of people in this part of Long Island in the 1600s. The Southampton Colonial Society has done a wonderful job of preserving the house and some of the actual items used by the original settlers. The table is set for dinner, the bunk beds are turned down for the children and a rare old Bible is set out for reading before bedtime. Stones from the original well are just outside of the side door, and the gardens and orchard have been designed to also recapture the flavor of seventeenth-century Southampton. There is an old copper sundial at the edge of the rear yard and a magnificent holly bush that has grown to the size of a tree just behind the well.

Like many Long Island historic sites, Halsey House is not open during the winter months, and it is recommended that visitors call ahead to (631) 283-2494 to verify the schedule. It is located at 249 South Main Street, and

the admission charge is four dollars for adults, with no charge for children under the age of seventeen. Like many similar historic sites on Long Island, Halsey House is something of a time machine, allowing visitors to get a sense of what life was like long before the traffic congestion on Sunrise Highway marked the entrance to Southampton.

WATERMILL GRIST MILL

It is no secret that people tend to take for granted all of the modern conveniences that we enjoy each day. Just remember the last time that your area lost electrical power during a storm and how you had to adapt to living without lights, heat, refrigeration and television. The early colonial settlers on Long Island had no electricity or any of the things that make our lives so much easier. They were uniquely self-sufficient but still needed some source of power, and a water mill was the state-of-the-art technology of its day.

In 1640, an English colonist named Edward Howell relocated from Lynn, Massachusetts, to Long Island, along with Thomas Halsey, whose house still stands in Southampton. Howell had operated a water mill in the Massachusetts colony and intended to build one in his new home as well. He is reputed to have been the wealthiest citizen in the area and also served in the position of magistrate. It is no surprise then that he was able to persuade the fledgling town government to give him a forty-acre parcel of land on a pond and the labor and funding to build another mill.

The first site was several hundred yards north of the present location on Mill Creek and was in operation by 1644. To take better advantage of the moving water by building a dam and other modifications, the mill was moved several times in the ensuing years. There are differing accounts of the date of the final move to its present location, but researchers at the Water Mill Museum place the final move at around 1789. In addition to a number of different locations, there were also different configurations of the water wheel to reflect changing technology or different industrial applications for the power that it produced. Its original configuration would have been a vertical wheel similar to what is in use today, but there is evidence that at one time the driving mechanism was what is known as a horizontal tub water wheel.

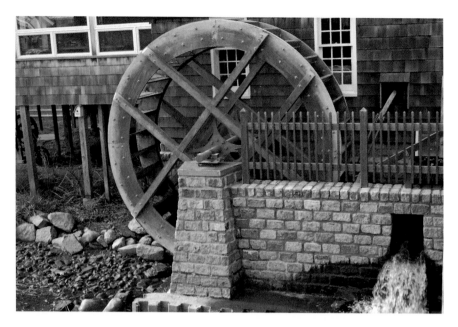

A side view of the gristmill showing the restored water wheel. *Photo by author.*

The water mill would have impacted almost every aspect of society in colonial times. Over the years, under the control of different owners, it was used to grind corn and grains, power weaving machinery, spin yarn and process wood pulp into paper. A man named John Benedict purchased the mill in 1833 and expanded use of the building to include the dyeing and processing of wool cloth. By the early 1900s, with the advent of other sources of power, the mill was shut down and the building used at various times as an ice storage house, ice cream factory, naval architect's office and outlet shop for articles made by the blind.

In 1921, the Ladies Auxiliary of Water Mill began the lengthy process of repairing and restoring the mill as a museum and historic site. It was not until 1976 that the mill was up and running again, and visitors to the site will note that the process of restoration is still continuing. The museum exhibits many artifacts that relate to the history of the site and features different exhibitions during the year that highlight local crafts and historic memorabilia. When planning a visit, check with the museum for its schedule and special events by calling (631) 726-4625.

Bibliography

"About Jackson Pollock." www.jacksonpollock.com.

"Alexander Turney Stewart." www.all-biographies.com.

"The Big Duck." Brochure published by Suffolk County Department of Parks and Recreation, Flanders, NY, n.d.

Bridgehampton Racing Heritage Group. "Bridgehampton Memories." www.bridgehamptonraceway.com.

"Camp Hero." www.camphero.net.

"Camp Upton." www.bnl.gov/bnlweb/history.

Center for Public Archaeology at Hofstra University. "William Floyd Estate." www.maap.columbia.edu.

Central Park Historical Society. www.grummanpark.org/Bethpagemarker.

Cheney, Margaret. *Tesla: Man Out of Time*. New York: Simon & Schuster, 1981.

Cold Spring Harbor Fish Hatchery & Aquarium. www.cshfha.org.

Cow Neck Historical Society. www.cowneck.org.

Cradle of Aviation Museum. "The History of Mitchell Field." www.cradleofaviation.org.

Custer Institute. www.custerobservatory.org.

Dade, George C., and Frank Strnad. *Picture History of Aviation on Long Island*. Mineola, NY: Dover Publications, Inc., 1989.

DeBragga, Joseph. "The History of St. Mark's Parish." www.stmarks-islip.org.

East Islip Historical Society. "Bayard Cutting Estate." www.eastislip.org.

"Fire Island Lighthouse." www.lighthousefriends.com.

"Fort Corchaug and Downs Farm Preserve History." www.southoldtown. northfork.net.

Friedman, Dave. *Pro Sports Car Racing in America.* Osceola, WI: MBI Publishing Co., 1999.

Friends of Science East. "Nikola Tesla." www.teslascience.org.

Hallockville Museum Farm. www.hallockville.com.

"Horton Point Lighthouse." www.lighthousefriends.com.

Hurt, Jethro M., ed. *Old Westbury Gardens: A History & Guide.* Huntington Station, NY: Hamilton Lithographers, n.d.

"John Holland." Department of the Navy–Naval Historical Center. www. history.navy.mil.

"John Philip Sousa." Performing Arts Encyclopedia. www.lcweb2.loc.gov/ diglib/ihas.

"Jupiter Hammon." www.poetry.about.com.

Latner, Ann W., ed. *Journal of the Cow Neck Historical Society.* Port Washington, NY, 2010.

Leita, John. "Bulova Watchcase Factory." Long Island Ruins and Remnants. www.li-ruins.com.

———. "Vanderbilt Motor Parkway." Long Island Ruins and Remnants. www.li-ruins.com.

"Montauk Point Lighthouse." www.lighthousefriends.com.

Morris, Richard Knowles. *John P. Holland.* Annapolis, MD: United States Naval Institute, 1966.

Nassau County Department of Parks & Recreation. www.nassaucountyny. gov/agencies/Parks.

National Carousel Association. "Nunley's Carousel." www.nationalcarousel. org.

National Park Service, U.S. Department of the Interior. "Sagamore Hill." www.nps.gov/sahi/history.

National Scrabble Association. "History of Scrabble." www.scrabble-assoc.com.

New York Defense Area. "Nike Battery NY-24." www.alpha.fdu.edu/bender.

"Oheka Castle." www.discoverlongisland.com.

Old Historic Long Island. "The Lloyd Manor House." www. oldhistoriclongisland.com.

Old Whaler's Church. www.oldwhalerschurch.org/History.

Oyster Bay Historical Society. "Jakobson Shipyard, Oyster Bay." www. trainsarefun.com/lirr/jakobson.

Planting Fields Foundation. www.plantingfields.org.

Port Jefferson Historical Society. www.portjeffhistorical.org.

Raynham Hall Museum. www.raynhamhallmuseum.org.

Rocky Point Historical Society. "RCA Radio Central Transmitting Station." www.rockypointhistoricalsociety.org.

Sagtikos Manor Historical Society. www.sagtikosmanor.com.

Sands Point Preserve. "Hempstead House." www.sandspointpreserve.org.

"Sands Point Seaplane Base." www.city-data.com/airports.

"Science Walking Tour." Public service brochure published by CSHL Department of Public Affairs, Cold Spring Harbor, NY.

Solecki, Ralph S., and Robert Grumet. *Fort Massapeag Archeological Site*. Washington, D.C.: U.S. Department of the Interior, 1993.

Southampton Historical Society. "Halsey House." www. southamptonhisatoricalmuseum.org.

Suffolk County Vanderbilt Museum. www.vanderbiltmuseum.org.

Three Village Historical Society. "William Sidney Mount." www.3villagecsd.k.12.ny.us.

U.S. Merchant Marine Academy. www.usmma.edu/about/History.

Village of Saddle Rock. www.saddlerock.org.

Ward, Ian, ed. *The World of Automobiles*. London: Orbis Publishing Ltd., 1974.

Ward Melville Heritage Organization. "Stony Brook Grist Mill." www. wmho.org.

Water Mill Museum. www.watermillmuseum.org.

Welles, Gordon, and William Proios. *Port Jefferson, Story of a Village*. Port Jefferson, NY: Historical Society of Port Jefferson, 1977.

INDEX

About the Author

Ralph Brady is a retired executive from the transportation industry, with more than twenty-five years of experience owning and operating a nationally known logistics consulting company. He is married with three children and five grandsons, soon to be joined by a new grandchild in July 2012.

Ralph and his wife, Madeline, have been residents of Long Island for more than forty years and enjoy both leisure and adventure travel. This has taken them to China and countries throughout Europe and the Caribbean and, in Ralph's case, to the slopes of Mount Kilimanjaro in Tanzania as well.

While some might consider it fulfillment of a "bucket list," Ralph has included skydiving, SCUBA diving, race car driving, glider piloting and ballooning in his list of adventures. He holds a second-degree black belt in Okinawan karate and has completed more than twenty full marathon road races. His affiliation with The History Press in publishing this book has allowed him to realize another one of his life's dreams.

Visit us at
www.historypress.net

· ·

This title is also available as an e-book